D

COLLAGE SOURCEBOOK

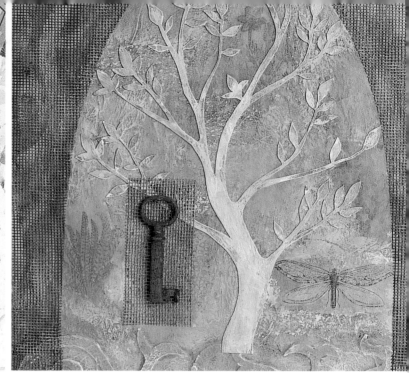

COLLAGE SOURCEBOOK

EXPLORING THE ART & TECHNIQUES OF COLLAGE

APPLE

Published in the UK in 2004 by
Apple Press
Sheridan House
112-116A Western Road
Hove BN3 1DD
UK

www.apple-press.com

ISBN 1-84092-465-9

10 9 8 7 6 5 4 3 2 1

Layout and production: Susan Raymond

Cover Images:
top left: Helen Orth; top right: Paula Grasdal;
bottom left: Paula Grasdal; bottom right: Dominie Nash

Grateful acknowledgment is given to Jennifer Atkinson for her work from
Collage Art: A Step-by-Step Guide and Showcase (Quarry Books 1996) on
pages 8–11 and pages 15–139; and to Paula Grasdal and Holly Harrison
for their work from *Collage for the Soul: Expressing Hopes and Dreams
through Art* (Rockport Publishers 2003) on pages 12–14 and pages
140–261.

Printed in China

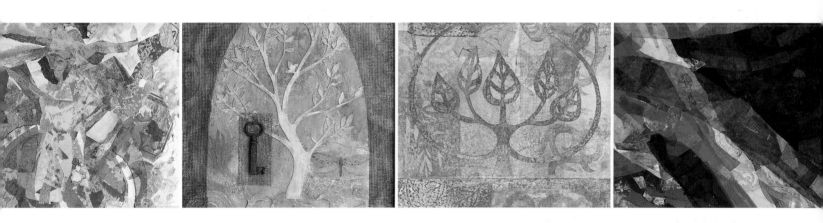

CONTENTS

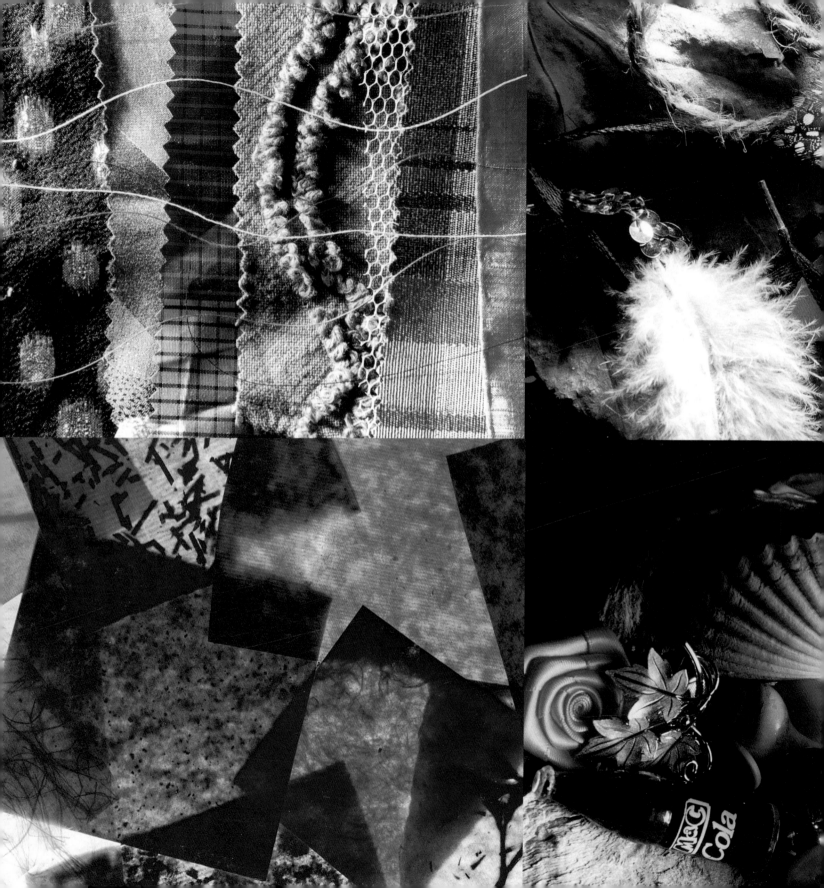

INTRODUCTION

Collage had a long, vital history as a folk art before it emerged as a fine art in the twentieth century. In Europe, Asia, and the Americas, all kinds of everyday materials were transformed into mementos and decorations: pictures made of matchsticks, straw, butterfly wings, or feathers; portrait silhouettes cut carefully from paper and framed; fancy paper Valentines garnished with bits of lace and cutout papers; and pressed flower arrangements. In the early 1900s, the modernist avant-garde adopted collage as a medium, making it an integral part of the evolution of modern art. It suited the modernists' radical reinterpretation of the picture plane (they rejected one-point perspective and the attempt to portray "real space" in two-dimensional work). Collage's celebration of common materials, typically considered beneath the purposes of fine art, also appealed to them—they wished to create art that could be reproduced easily, made from readily available materials.

Collage continues to appeal to professional artists (even those who specialize in other media), and amateurs as well, because it presents a personal, spontaneous way of working with materials that are easy to obtain. A wealth of books on the discipline of collage is available to those who wish to study its origins and development. This book provides information on paper and fabric collage, collagraphy, and found object collage, to assist and inspire both those who are just discovering the medium of collage, and those who would like to add to their knowledge and skills. As you will see, the creative possibilities of working with collage are infinite.

A SHORT HISTORY
of Collage

C. P. Kunstadt
In Reverence
Collage with mixed media
4" x 6" (10 cm x 15 cm)

Ellen Wineberg
White Bird on Black
Collage with oil and shards on wood
12" x 15" (30 cm x 38 cm)

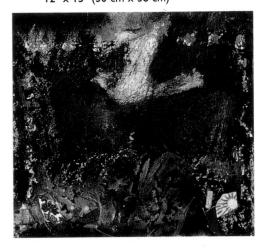

In 1912, Pablo Picasso and Georges Braque began making paper collages according to the principles of cubism. Their two-dimensional collages employed newspaper clippings, colored papers, tobacco wrappers, and wallpapers. They favored printed papers with trompe l'oeil patterns resembling materials such as wood grains and chair caning, and they often embellished their works with painted details or charcoal drawings.

Once the cubists adopted collage, other artists and movements recognized its potential. In Italy, the futurists used collage to convey the ideals of the machine age—speed, dynamism, and mechanization. Russian constructivists employed collage in the posters that heralded the Russian Revolution. Dadaists and surrealists of the 1920s stretched the boundaries of the medium, incorporating found objects, mixing elevated subject matter with mundane or earthy topics, and placing texts or headlines in unusual contexts to impart new meaning to them.

Marcel Duchamp, the most well known Dadaist, created "ready-mades," found objects to which he added text. His most scandalous ready-made, entitled Fountain, was fashioned from a urinal and bore this signature: R. Mutt. Duchamp also created collages that combined his own artwork with mass-produced images. Two other well known Dada artists, Kurt Schwitters and Max Ernst, used collage extensively. Schwitters integrated memorabilia from his personal life (tickets, newspapers, letters) into his collages. Ernst, deeply interested in the new field of psychiatry, employed the principle of automatism—suspending the conscious mind's control in order to release subconscious images. Collage enabled him to access these images and render them in his work. Ernst achieved subtle effects by exploiting the medium of paper, using tracings and rubbings, as well as damaging certain images in his work through peeling or tearing.

The works of Joseph Cornell form a watershed in the history of collage. He created arrangements of objects—old bottles, toys, trinkets—in small boxes (these three-dimensional collages are often called assemblages), as well as working with paper images. Surrealistic juxtapositions, such as the printed image of a human being's body topped with the head of a bird, are a

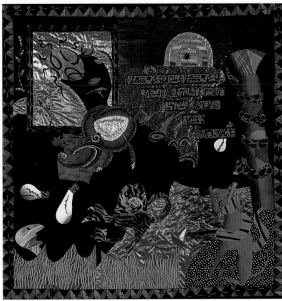

hallmark of his work. Though associated with the surrealists, he also cited the influence of Hans Christian Andersen's *Great Screen* (1662), which combined paper cutouts of outdoor scenes, architectural elements, and myriad faces on a large folding screen.

In the 1940s, abstract expressionists appropriated collage to express the pioneering spirit of the artist. Robert Motherwell adapted paper collage to generate abstract forms from materials such as wine bottle labels, soap boxes, book jackets, and cigarette packages, typically emphasizing torn edges. He considered collage to be a form of play, a medium that allowed him to be gestural and spontaneous. Robert Rauschenberg, however, used collage techniques to challenge the abstract expressionists' devotion to pristine surfaces and nonrepresentational themes in his "combine paintings" such as *Bed* (1955), which featured a mattress and bedclothes that have been painted.

Jasper Johns continued the development of collage in the 1950s with three-dimensional pieces often incorporating dartboards (their concentric circles recur as a motif in his work) and other large items, such as molds of heads. He frequently

embellished these works with paint. During the pop art movement of the 1960s, collage artists focused on items representing pop culture, such as televisions sets, advertisements, telephones, comic strips, and food packaging— variously spoofing them, transforming them, or giving them an eerie life of their own. For example, Claes Oldenberg's large-scale soft sculptures re-create everyday objects in unusual materials, such as a huge ice cream cone rendered in fuzzy fabric.

More recently, neo-Expressionists have incorporated collage elements into primarily painted surfaces. Julian Schnabel, for example, has attached crockery to his painted canvases. Jeff Koons has continued to interpret elements of pop culture, as in his treatment of a balloon twisted into an animal shape and cast in ceramic with a metallic finish. Collage also well expresses the postmodern nonlinear view of time, in which fragments of the past can overlap with the present. The viewer can consider the meaning of an item in its original context as well as the ramifications of its new position.

Clara Wainwright
Out of Order
Paper with mixed media
54" x 54" (137 cm x 137 cm)

Betty Guernsey
Every Time We Say Goodbye
Paper with mixed media
20" x 30" (51 cm x 76 cm)

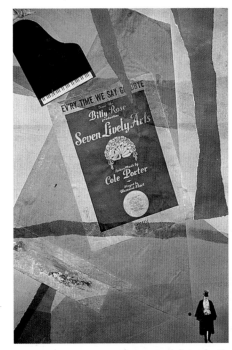

⊚ COLLAGE BASICS ⊚

BASIC TECHNIQUES

When working with paper, it is important to choose your adhesives carefully. Rubber cement should be avoided because over time it dries out and loses its ability to hold. Acid-free glues such as PVA will dry clear and won't stain papers as they age. Many collage artists use acrylic mediums (available in matte or gloss finish) to adhere papers because they dry clear, are easy to use, and can add translucency to light papers such as tissue or rice paper. When working with any kind of paper or board support, always coat both sides first with acrylic medium to keep the support from warping.

Many artists use acid-free papers where possible, but most found papers (newspapers, magazines, vintage papers) aren't pH-neutral. You can minimize discoloration by encasing pieces in acrylic medium, but it's likely they will still change over time. This is no reason to avoid them—found papers add character to your work and their ephemeral nature is part of their charm.

For assemblages, use industrial-strength craft glues such as E6000 for adhering heavy objects, metal, and other nonporous surfaces. And be open to alternative ways of joining materials: Transparent or masking tape, straight pins, staples, string, thread, wire, tacks, grommets, and brads are all effective and also add interesting details and textures to a piece.

BASIC COLLAGE SUPPLIES

In addition to the materials specified for each project, you'll need to have the following basic collage supplies on hand: newspapers to protect your work area, scissors (small and large), a craft knife and self-healing cutting mat, brayer, metal ruler, pencil and eraser, artist's and foam paintbrushes in assorted sizes, water jar, paint palette, and a hair dryer (for cutting drying time). Susan Pickering Rothamel, author of *The Art of Paper Collage*, recommends using a viewfinder—an empty picture-framing mat—to aid in the composition of your piece.

Most of the projects require access to photocopiers and several entail computers and black-and-white or color printers. We assume people will have the following common household items on hand: paper towels, rags, tweezers, cotton balls and swabs, rubbing alcohol, masking tape, and a stapler, as well as basic tools such as a hammer, screwdrivers, wire cutters, needle-nose pliers, and sandpaper.

To avoid pencil lines on the front of the collage, trace the pattern on the back of each paper, but be sure to place the pattern piece facedown as well, to ensure the correct result. Then carefully cut out the collage pieces.

You can manipulate the paper pieces in various ways before affixing them to the collage surface. Cutting paper produces a clean edge; use a narrow, pointed knife blade on delicate papers and a razor blade or X-Acto knife on thicker papers, such as poster board. Folding paper creates a softer straight edge, with some relief. Tearing paper, unless you use a ruler, will not result in a straight edge but produces a random, spontaneous feeling. Paper can also be crumpled, punctured, wetted, or decorated with paints, color pencils, block prints, and so on.

Get ready to glue the pieces into place after you are pleased with the overall composition of the collage and the shape, texture, and decoration of each piece. Keep a damp cloth or paper towel ready, to wipe excess glue off your hands as you work. Plan

before you begin; it might be best to affix the larger background pieces first, and then add the details. Or you may wish to assemble complicated elements of the design, such as a flower with petals made of different papers, before securing them to the collage.

Coat one of your collage pieces evenly and sparingly with glue. A brush will be useful if you are using a runny glue. Then apply it smoothly to the collage, using gentle pressure with the heel of your hand. You might place a cloth or paper between your hand and the collage, to keep the surface clean. Carefully follow this process with each piece, and the collage will take shape neatly before your eyes. Let the piece dry completely before adding the finishing touches—a bit of painted or penciled color, another paper detail or two, a light acrylic wash, or whatever your work of art inspires you to do.

▲ **Susan Gartrell**
Easter Island
Paper with mixed media
5" x 6.5" (13 cm x 17 cm)

◀ **Timothy Harney**
The Piano Room
Paper with acrylic and mixed media
13.75" x 16.75" (35 cm x 43 cm)
Courtesy of the artist and Clark Gallery

▶ **Robin Chandler**
Genesis, Genesis
Paper collage
38" x 48" (86 cm x 122 cm)
Photo by Kay Canavino

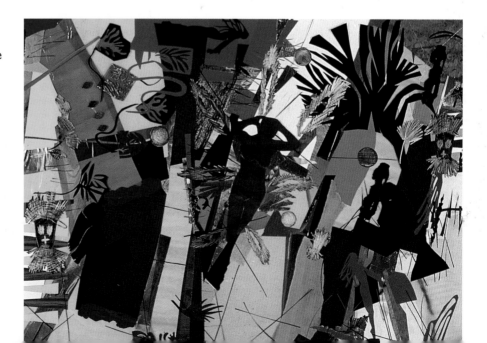

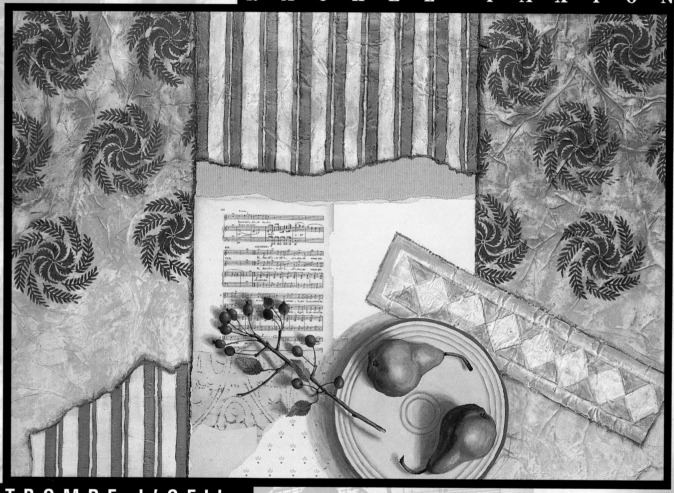

RACHEL PAXTON

TROMPE L'OEIL
Paper Collage

Pattern and the relationship between art, nature,

and spirituality have been the focus of Rachel Paxton's work for the past 15 years. Her paper collages address life, death, and the passage of time, and they project a calm, contemplative atmosphere. They also reflect her allegiance to a time when humanity held greater respect for nature, craft, and religion.

Although Paxton once constructed painted abstract assemblages (three-dimensional collages) made from found objects and wood, she now concentrates on collages that are composed of paper only. Still, her background as a trained textile designer is evident in her work. She creates small paintings that simulate specific types of fabrics—striped mattress ticking and nineteenth-century wallpaper designs inspired by William Morris, for example—and affixes them to her collages. Her ability as a painter shows in the carefully rendered details. By using block prints of certain designs rather than hand-rendering them, she creates a consistent pattern. She prints her designs on beige or gray Arches paper or on tissue paper, to which she later adds texture by crumpling or painting.

In her most recent work, Paxton has examined the passage of time by using fruit still life as a metaphor for the cycle of human life. She uses a number of techniques to evoke the passage of time. Coffee-dyeing gives an aged quality to certain papers; she simply soaks the paper in coffee for a few minutes and then lets it dry naturally. The result is much like "foxing," the browning effect produced by the aging process in papers that contain wood acid. Since foxing typically affects older paper, this type of staining is recognized as antique. Elements such as old sheet music and faux vintage fabric lend an air of antiquity to her collages. For the viewer, these familiar objects from the past evoke memories and create a feeling of nostalgia.

Paxton also tries to produce a sense of altered space in her collages. Although the background of her work is flat, Paxton introduces shadowing in the fruit still life to disorient the viewer, who seems to be positioned both within and above the collage. This juxtaposition expresses the discomfiting relationship between the past and the present, as well as the shifting nature of human perception.

◀ *Pinwheel Chamber, Late Afternoon*
Paper with mixed media
32" x 40" (81 cm x 102 cm)

MATERIALS

- acrylic paints in a variety of colors
- assorted specialty papers
- containers for mixing
- easel
- matte acrylic gel
- newsprint
- number 2 pencils
- paintbrushes
- palette knife
- paper palette
- paper towels
- printmaking paper (such as Arches) in buff
- scissors or other cutting tools
- spotlight

In preparing to create a paper collage, the artist chooses from her stores of gravestone rubbings, old sheet music, tracings of wallpaper, block prints with motifs adapted from fabric designs, and coffee-dyed nautical maps.

Tinting Paper

In addition to tinting paper with coffee, you can try other liquids to produce a variety of hues. Green tea produces a nice effect.

1 For the preliminary design, Paxton lays out the paper painted with a mattress ticking pattern, sheet music, and crumpled tissue printed with repeating pattern motifs. She tears and cuts the original sheets to create textural interest and a balanced composition. She then fine-tunes the composition by cutting or tearing small bits of paper and by rearranging and adding pieces.

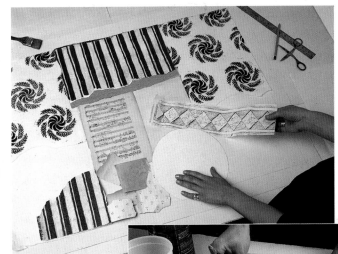

2 Paxton glues the bottom layer into place first; she turns the torn paper over onto a pile of clean newsprint, which keeps the edges of the collage free of excess glue. She then applies acrylic gel with a 1 1/2-inch brush, using strokes that radiate from the center of the paper to the edges, covering the paper completely. Paxton then places the piece onto the collage and makes it adhere smoothly by applying even pressure with the heel of her hand. Placing a piece of clean tissue paper over the freshly glued paper before pressure is applied will keep the surface clean. After all the papers have been glued into place, the collage is allowed to dry completely.

3 Next, Paxton applies acrylic gel to portions of the crumpled rice paper, which was glued over the block print pattern for textural interest. After it dries, the acrylic gel resists the light acrylic wash that she is shown brushing over the surface, thus leaving some areas untinted. This subtle coloring heightens the textured effect of the crumpled paper.

4 At this point, a difficult stage of the process begins—the addition of the painted still life. Paxton determines the position of the fruit on the plate and the placement of shadows by looking at the still life from above, under direct light. Once the composition of the still life and its placement have been decided, the artist sketches it directly onto the collage, using a number 2 pencil.

5 The artist now begins to paint the still life onto the collage with acrylic paint, which is easily mixed and water soluble. She begins this process only after the acrylic gel and subsequent washes have dried completely.

Making a Deckle Edge
To create the look of a deckle edge, use a ruler when tearing the paper pieces. This ensures a straight edge but produces a soft effect.

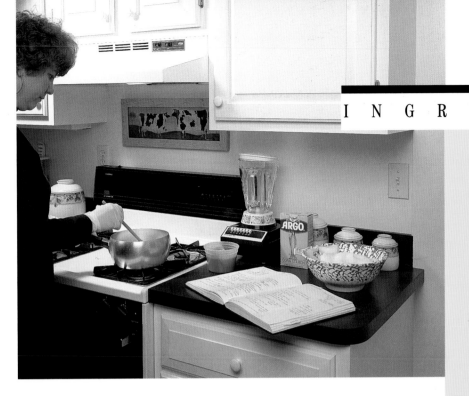

blender

cooking pot

cornstarch (1 cup)

disposable plastic cups

**liquid pigments
(such as Guerra)**

plastic spoons

rubber gloves

stove or hot plate

strainer

water

M cCarthy uses a traditional method of making pigmented cornstarch paste. She adds cornstarch to a pot of boiling water, stirs constantly until it thickens, and then lets it cool to a gel. Then she colors the paste with liquid pigments.

KAREN L. McCARTHY'S CORNSTARCH PASTE RECIPE

Dissolve 1 cup of cornstarch into 1 cup of room-temperature water. Place the mixture in a pot, and heat it slowly. Gradually add 3 more cups of water to the mixture, and continue heating, stirring constantly, until the mixture boils. (Caution: bubbles may pop messily; be careful!) While stirring, boil the mixture for 2 to 3 minutes, until it is thick and forms a gel. Let it cool completely.

Remove 1 cup of the mixture, and place it in a blender. Add 1 cup of water, and blend it until smooth; this makes a thin paste. Add less water if you would like a thicker paste for a particular project. Strain the paste before using it.

To add color, simply use a plastic spoon to stir paints or pigments into cups of paste. Never place pigmented paste into a blender that will be used for food preparation. Pigments stain easily and should be handled with care (wear rubber gloves). The paste will keep for several days if stored in the refrigerator or another cool place.

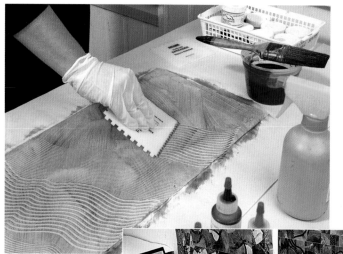

1 McCarthy brushes the cornstarch mixture onto the paper with a paintbrush, taking care to cover the surface completely. She makes patterns and textures on the surface with implements such as combs and cookie cutters, to add shadows, depth, and rhythm. She then allows the paper to dry completely. A second layer of color can be applied after the first one dries. Colors will lighten somewhat as they dry. The artist often spends a week at a time on this process, making enough pigment-dyed papers to last for a couple of months.

2 With a variety of colored, patterned papers at hand, McCarthy is ready to begin a collage. First, she sketches a full-scale design onto newsprint and selects papers from her well-organized collection.

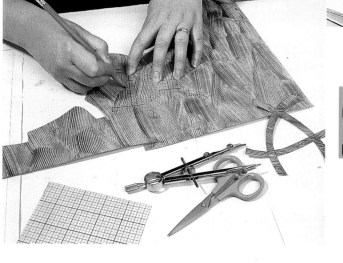

3 McCarthy has cut templates of specific collage shapes. Here, she traces the outline of one of the shapes onto her patterned paper. This motif will form part of the central panel of the collage.

After cutting out all the shapes, McCarthy adds shading and texture to their surfaces by reworking them with a variety of materials: fabric paint, paste, colored pencils, and acrylic and metallic paints.

At this stage, McCarthy glues the smallest collage pieces onto the larger squares. Although she has precisely drawn the collage's overall design, she often assembles the entire collage (using a bit of removable cellophane tape folded over and applied to the back of each piece) before beginning to glue the pieces together. Thus she can fine-tune her design as a visual whole and ensure the proper positioning of each piece.

Next, the artist considers where she will apply stitching to the collage. Then she assembles one section at a time, gluing the pieces on a paper backing cut to fit. After the glue has dried, she draws lines that will guide her stitching, using a pencil with a ruler or compass.

7 McCarthy stitches along the penciled lines. Working with small sections of the collage simplifies the machine sewing. She has already tested samples of the papers to determine proper needle size and tension—a step she considers absolutely essential. Needles that are too small may break; McCarthy often uses Schmetz jeans/denim number 16 needles for work with thick papers.

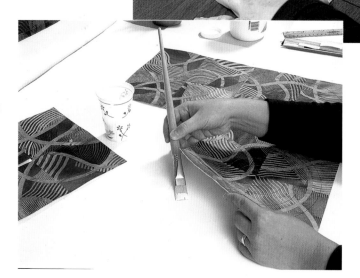

8 Once all the sections of the central panel are complete, McCarthy attaches them to the full-scale paper backing of the collage. She applies white PVA glue with a 1-inch brush, to make an even, spare application.

Stitch Tip

You might use hand stitching rather than machine stitching to embellish paper, for both practical and aesthetic reasons. Machine stitching can be awkward for larger works; hand stitching allows more freedom of choice in threads and yarn, and may yield a freer line. Hand stitching is, however, more time consuming.

9 Here the artist finishes the edges of the four central-panel squares with a zigzag stitch.

10 McCarthy next attaches the stitch-embellished border of the collage, using a minimal amount of glue. Individual pieces are weighted for drying, and to prevent wrinkling.

11 After the glued border has dried, McCarthy finishes the edge between the central panel and the border with a zigzag topstitch. Because the entire collage must be handled to complete this final step, great care must be taken not to bend or wrinkle the delicate papers. McCarthy's background in sewing serves her well here.

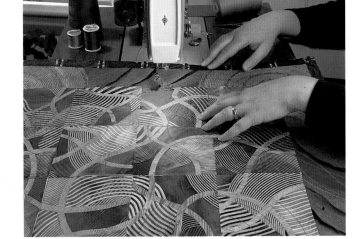

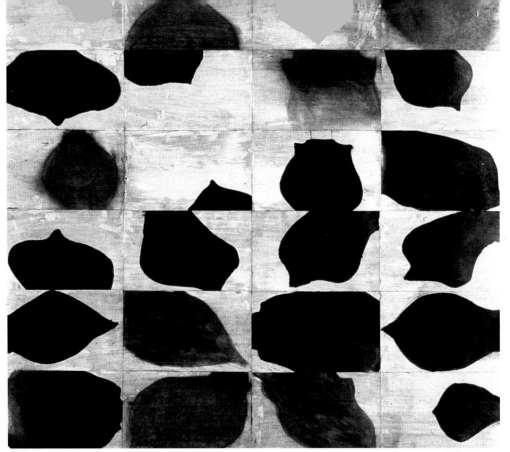

◀ **Gina Occhiogrosso**
After Millay
Mixed media paper collage
18" x 20" (46 cm x 51 cm)

▼ **Gina Occhiogrosso**
Untitled
Mixed media vellum collage
14" x 14" (36 cm x 36 cm)

Eloise Pickard Smith ▶
Hanaogi
22.5" x 30" (57 cm x 76.2 cm)

GALLERY

◀ **Felicia Belair-Rigdon**
Untitled
Mixed media collage with handmade paper
30" x 39" (76 cm x 99 cm)

Felicia Belair-Rigdon ▲
From a Long Time Ago
Mixed media collage with handmade paper
24" x 32" (61 cm x 81 cm)

◀ **Susan Gartrell**
Woods Hill
Paper with mixed media
4" x 4" (10 cm x 10 cm)

Photo by Kay Canavino

▼ **Gordon Carlisle**
Repose
Collage with acrylic painting enhancement
3.5" x 5.5" (9 cm x 14 cm)

▲ **Gordon Carlisle**
Lady of the Lake
Collage with acrylic painting enhancement
12" x 8.75" (30 cm x 22 cm)

▲ **Karen McCarthy**
Moksha-Patamu: For Beatrice Wood
Paper with pigmented starch paste, thread, and colored pencil
26" x 26" (66 cm x 66 cm)

Rachel Paxton ▶
Pinwheels & Pears, Early Morning
Paper with mixed media
21" x 38" (53 cm x 97 cm)

▼ **Nancy Virbila**
Summer Sun
Paper with mixed media
20" x 16" (51 cm x 40 cm)

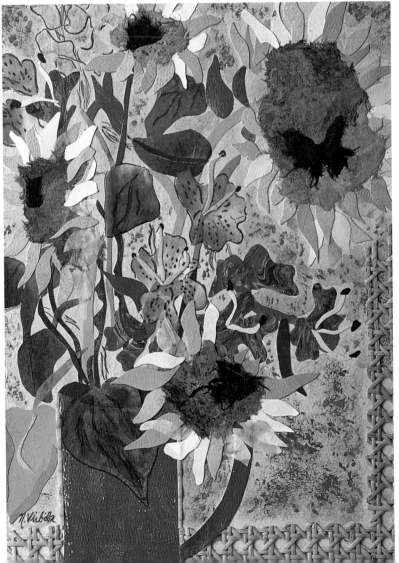

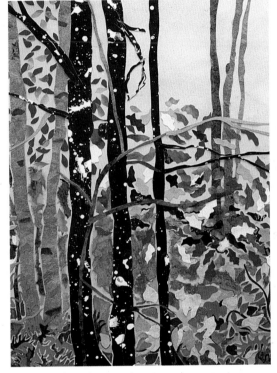

▲ **Nancy Virbila**
Porter's Woods
Paper with mixed media
20" x 24" (51 cm x 61 cm)

▼ **Robin Chandler**
The Lesser Peace #9
Paper collage
18" x 24" (46 cm x 61 cm)

▲ **Robin Chandler**
The Lesser Peace #6
Paper collage
18" x 24" (46 cm x 61 cm)

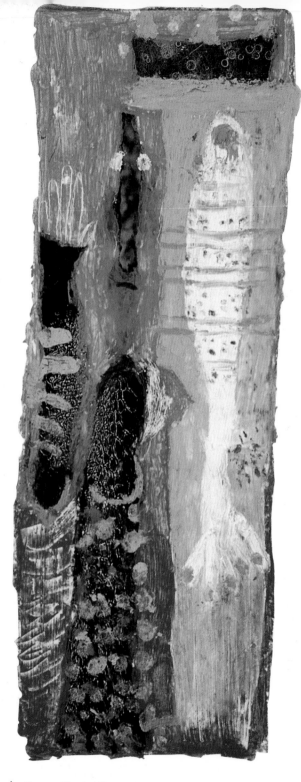

▲ **Susan Gartrell**
Catch of the Day
Paper with mixed media
3.5" x 9.25" (9 cm x 23 cm)

Photo by Kay Canavino

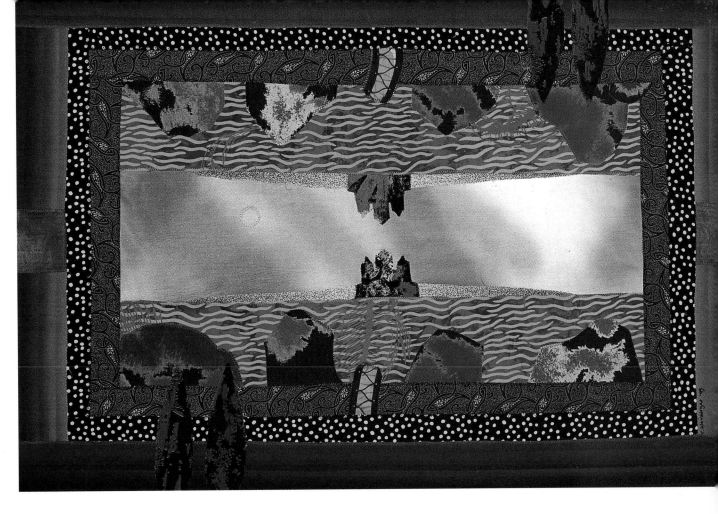

more prominent role. For displayed stitching, your choice of thread or yarn becomes an important part of the design process. Standard cotton, polyester, and silk machine-sewing threads might suit a project, but other possibilities should also be considered: metallic threads, shiny mercerized cotton, matte cotton embroidery floss, or silk mono-filament for hand stitching extremely delicate vintage fabrics. Be sure to determine whether a thread is suitable for handwork or machine stitching, and use it accordingly.

Finally, sewing notions such as braid, bias tape, ribbon, piping, and other trimmings are readily available in fabric shops to enhance your collages.

Though you might come to favor a particular type of fabric, explore them all!

▲ **Clara Wainwright**
Icbal's Vision
29.5" x 43" (75 cm x 109 cm)

Fabric

TECHNIQUES

To begin a fabric collage, you will need some

basic tools and materials. Find a few pairs of sharp scissors, including a small pair for delicate fabrics and detail work, and a large pair for cutting broad areas and thicker pieces of fabric. Pinking shears might be used to create an interesting cut edge. An iron is also necessary because, unfortunately, most fabrics have a tendency to wrinkle! Also, stock up on needles, threads in a variety of colors, sewing pins, a linen tape measure, a ruler, some tailor's chalk, a selection of soft pencils, and some tracing paper.

Next, gather your hoard of fabrics, and create a design. At a minimum, you will need a sketch to follow as you work. For your first project you might choose an image to reproduce in collage, such as a poster or a drawing of your own. Select fabrics that correspond to the image's

colors, shapes, or textures, such as yellow corduroy for wheat fields, green velour for fir trees, and shiny blue satin for the sky. Find a large piece of material for the background that might form part of the image or serve as a complementary border.

Next, cut out the individual shapes. You may use templates based on your design or work freehand. Treat fabric edges carefully; they can make the difference between a successful piece of work and a valiant but unsatisfactory effort. Edges of fabric can be finished in a number of ways: torn, cut, hemmed, bound, or topstitched. To tear a piece of fabric, make a small cut with sharp scissors, and then rip it gently. Cutting should be done carefully with scissors. Experiment with cutting or tearing a small swatch of your fabric to see whether the edge holds its shape or has a tendency to ravel; match your technique with the effect you want. Hemming makes a soft, finished edge with a bit of relief.

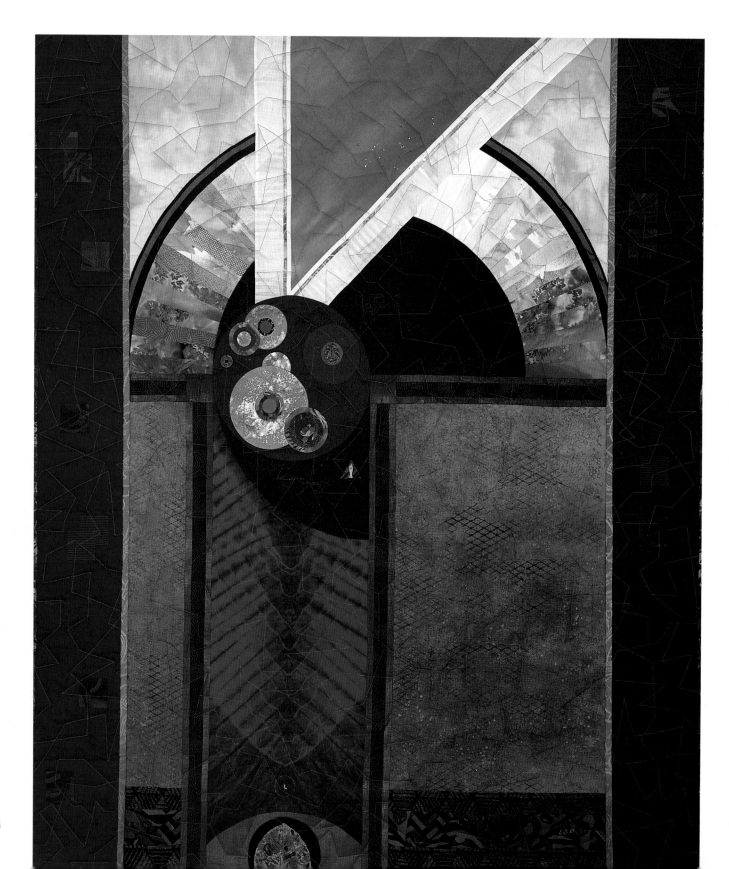

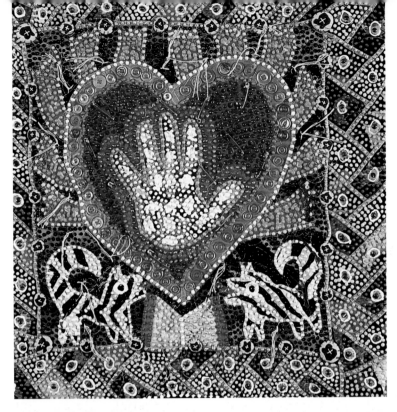

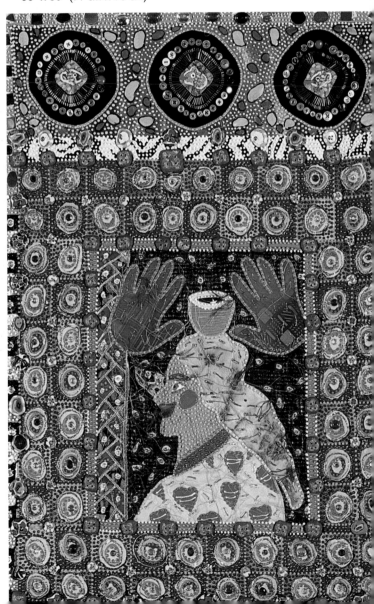

Therese May
Hearts + Hands
Embellished quilt
20" x 20" (51 cm x 51 cm)

▼ **Therese May**
Child #6—Sandy
Embellished quilt
36" x 30" (91 cm x 76 cm)

▲ **Dominie Nash**
Sky Song 3
46" x 72" (117 cm x 183 cm)

Erika Carter ▶
Confinement
Art quilt
65" x 45" (165 cm x 114 cm)

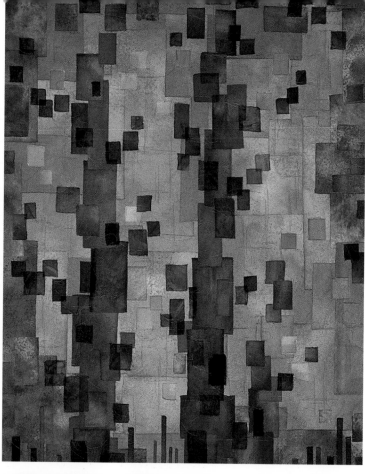

Erika Carter ▶
Reminiscent
Art quilt
60" x 44.5" (152 cm x 113 cm)

▲ **Barbara Mortenson**
Untitled
Fabric collage
3" x 5" (8 cm x 13 cm)

◀ **Barbara Mortenson**
Untitled
Fabric collage
3" x 5" (8 cm x 13 cm)

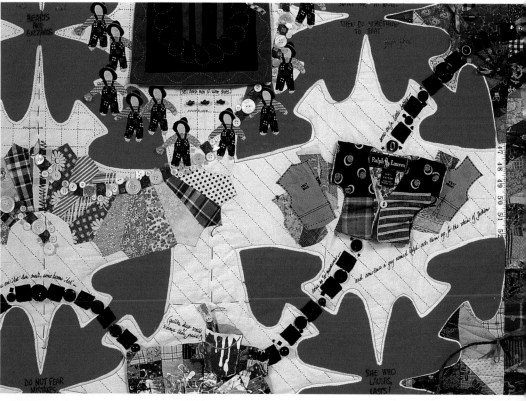

Sandra Donabed
Hearts + Gizzards
Quilt with fabric collage
72" x 78" (183 cm x 198 cm)
(detail right)
Photos by David Caras

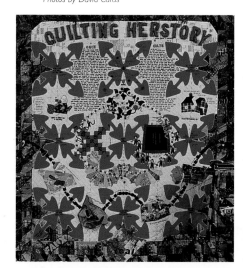

◀ **Barbara Mortenson**
Untitled
3" x 5" (8 cm x 13 cm)

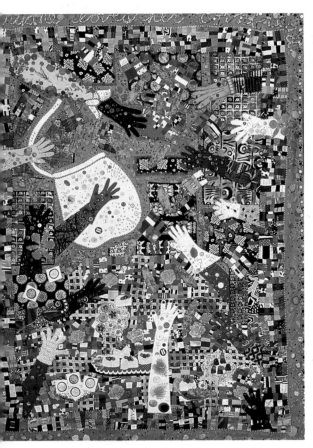

▲ **Jane Burch Cochran**
Devotion
Embellished art quilt
68" x 85" (713 cm x 216 cm)

Photos by Pam Monfort

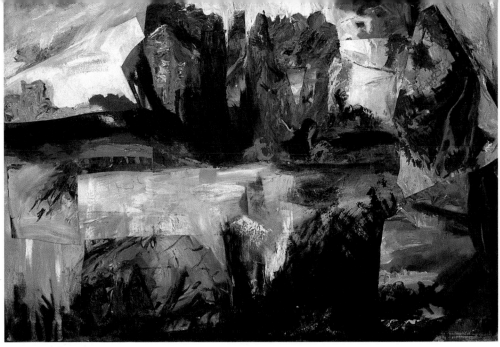

▲ **Carol Andrews**
Untitled
Fabric with oil and wax on canvas
27" x 38" (69 cm x 97 cm)

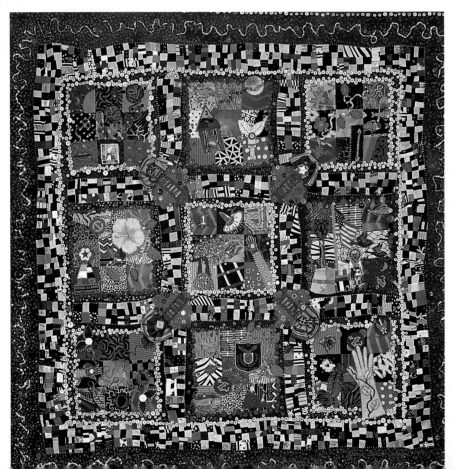

Jane Burch Cochran ▶
Life Starts Out So Simple
Embellished art quilt
68" x 68" (173 cm x 173 cm)

Photos by Pam Monfort

▲ **Carol Andrews**
Untitled
Fabric with watercolor, crayon, ink, latex,
and wrapping paper on canvas
23" x 30" (58 cm x 76 cm)

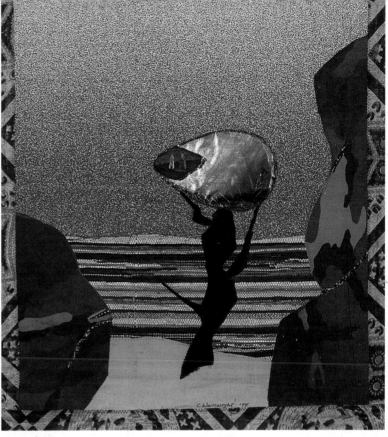

▲ **Clara Wainwright**
Waiting for Bosch
Fabric collage
26" x 22.5" (66 cm x 57 cm)

◄ **Clara Wainwright**
20th Anniversary Quilt for First Night
Fabric collage
100" x 77" (254 cm x 196 cm)

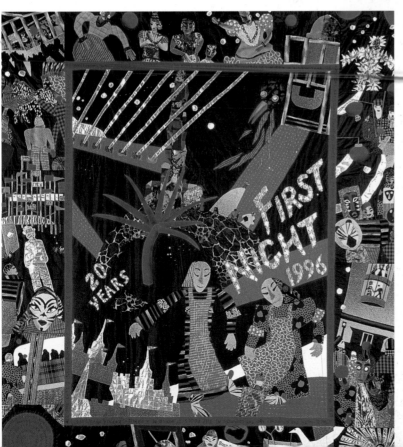

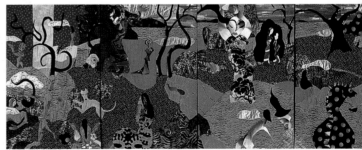

▲ **Clara Wainwright**
*Summer and Gauguin's Unanswered
Questions*
Fabric collage
48" x 108" (122 cm x 274 cm)

Collagraphy

Collagraphy, the process of making a print from a collage plate, has developed from traditional printmaking methods and the discipline of collage. Although a collage is assembled in the usual manner, it is not the end result; instead, the collage serves as a plate that transfers its textures, shapes, and lines (which must be expressed in relief) to a sheet of paper by means of a printing press. The end result is a two-dimensional work on paper.

The whole range of collage materials that impart texture and dimension—shoestrings, Mylar cutouts, textured fabrics, stalks of wheat, masking tape, scraps of lace, corrugated cardboard, twine, sandpaper, loofah fibers, lengths of macramé, leaves, sequins, tiny pebbles, paper doilies, feathers, crushed eggshells, twigs, and so on—may be affixed to a base (though certain techniques unique to this medium must be employed) to create the evocative juxtapositions and exploration of diverse materials and themes that characterize collage.

Robert Kelly
Kairos V
Collograph
39" x 32" (99 cm x 81 cm)

Jennifer Berringer
In the Balance
Monoprint
32" x 40" (81 cm x 102 cm)

A plate and press can be used to produce a single image or a series of impressions of that image; however, in collagraphy it is sometimes difficult to produce a number of impressions from one plate, because some collage elements may become flattened or distorted after the first impression.

A collagraph's main elements include composition, color, and texture. Its composition is determined by the arrangement of collage elements; its colors result from the selection and application of printing inks or paints to the collage plate; its visual textures reflect those of the particular collage elements. Some artists embellish their prints with glued-on details such as bits of paper and artwork, threads, and wires; others enhance them with hand-rendered touches in paint, colored pencils, or other media.

Collagraphy requires more equipment than other forms of collage, but still constitutes an approachable and pleasantly

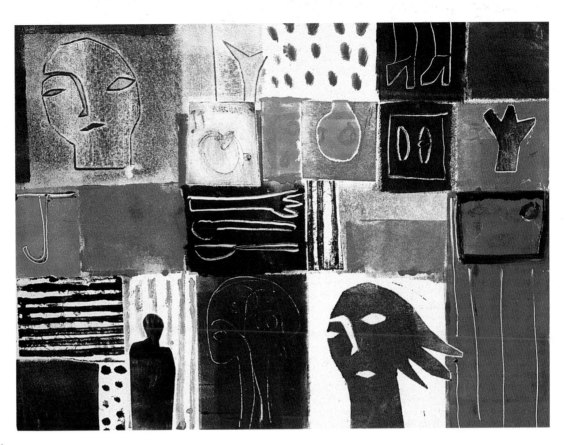

Deborah Putnoi
the J in my life
Monoprint
18" x 24" (46 cm x 61 cm)

experimental, improvisational way of creating art. Though primarily a fine art, collagraphy can also be used to create beautiful functional items such as greeting cards, book covers, posters, and illustrations.

Although both are printmakers, the two artists represented in this chapter differ in their approaches to creating collagraphs. Jennifer Berringer employs traditional printmaking techniques to execute her subtle, large-scale collagraphic images. Deborah Putnoi's approach is anything but traditional—her create-as-you-go style results in bold prints alive with spontaneity.

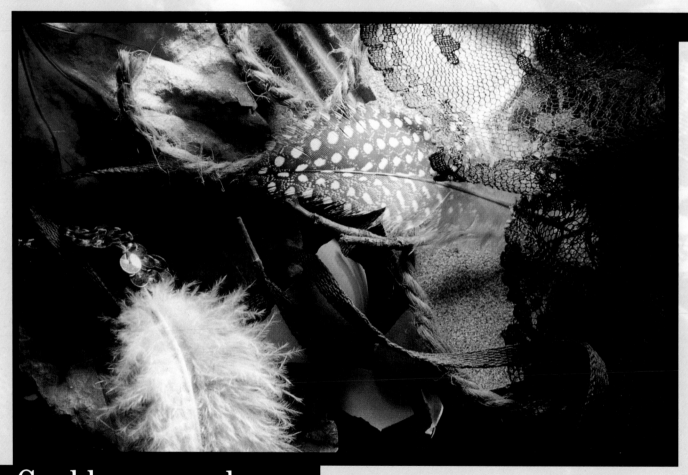

Collagraphy
MATERIALS

To create a collagraph, you will need special

materials and equipment, including a base, collage elements, glue, inks or paints, papers, brayers and brushes, and a printing press or other means to transfer the image from the collage plate to the paper.

First, select a base for the collage elements; the elements will be glued to it to form the plate. If a hand-printing technique will be used instead of a press, you have great freedom in choosing the base—corrugated cardboard, mat board, and even cardboard from shirt packaging are all suitable. If a press is to be used, you will need a much sturdier backing, such as Masonite, canvas board, a metal sheet, Plexiglas, linoleum, or plywood; the base's maximum thickness should be $1/8$ inch (it will be easier to run it through the press if its edges are beveled; you can sand the edges to achieve this). Also, consider the size of the press when deciding on the dimensions of the base.

Next, choose the elements of the collage. Remember that texture and raised (or recessed) patterns will be transferred to the print, but shapes that are not defined in relief will not show up. Also, an item's thickness and porosity must be considered. Elements that are thicker than $1/16$ of an inch will be difficult to print, though you might make an impression of a thick item, such as a jar cap or a door hinge, with modeling paste; it will pass more easily through a printing press and will create a faithful image of the original item. Porous items, such as fabrics and papers, must be treated to make them nonporous, or they will absorb ink and simply print a blurry splotch that lacks the definition and texture of the collage element. Applying a solution of acrylic medium and water will accomplish this.

To secure the collage elements onto the base, you will need a glue that both bonds well with a particular element and will remain strong yet flexible in the printing process. Acrylic gel and PVC glues such as Elmer's Glue-All and Sobo Premium Craft & Fabric Glue will affix cardboard, paper, and cloth successfully.

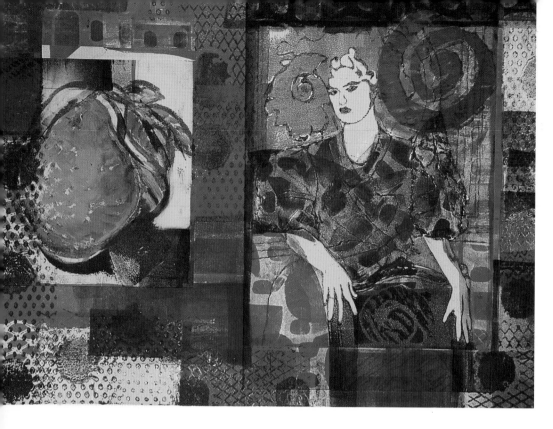

Emily Myerow
Pear Woman (Spring)
Monotype collage
14" x 18" (36 cm x 46 cm)

Rubber, metal, and wood need special fixatives such as epoxy resins, superglues, and wood glue.

Once the collage plate has been constructed, choose the ink or paint (oils, acrylics, and watercolors are all suitable). Each medium offers a different effect. Water-based paints and inks are easier to clean up because they do not require the use of a solvent. However, printing inks and oil paints offer greater permanence and reliability. (Although oil paints were once preferred over acrylics because of their quality of color, recent advances in the manufacture of acrylic paints have made this judgment obsolete.) Choose a paint or ink according to

the look you want for a particular collagraph. A given work can combine many colors or concentrate on a single hue.

Brayers (hand-held rollers used to apply the ink or paint to the collage plate) are made of hard or soft rubber, plastic, or gelatin, and they range in size from 1½ inches to 3 inches (3.8 cm to 7.6 cm) in diameter, and up to 2 feet (61 cm) in roller length (though for most projects, rollers of 4 to 6 inches (10.2 cm to 15.2 cm) in length will suffice). The hardness or softness of the roller will affect the application of color—a hard roller will coat only the uppermost surfaces of the collage plate, whereas a soft roller will push the ink into crevices and

depressions. Some printmakers use the end of a tightly rolled length of felt to daub color onto the plate; when the end becomes overused, it can be cut off, bringing fresh felt to the surface. Paintbrushes are not required in the printmaking process, but they can be helpful in applying details. You may also need to wipe excess ink from the plate—cheesecloth, newspaper, or a block of wood can be employed to create different effects.

Although several kinds of paper can be used to make a collagraph, printmaking papers such as Arches and Rives are the best choices. Manufactured specifically for printmaking, they are absorbent and

Debra L. Arter
Flight Over
Collagraphy with *chine collé*
9.5" x 9.5" (24 cm x 24 cm)

resist tearing. In general, papers with a high rag content will withstand the printing process well and won't discolor or disintegrate over time. Make sure to cut the paper with ample margins—they should be at least 2 inches (5 cm) larger than the plate at each side. The paper should also fit the press easily. Remember that the paper must usually be dampened before printing can begin.

If you do not have access to a press and wish to create a collagraph by hand, you will need a baren. This rubbing tool is a round disk, 5¹/₂ inches (13.4 cm) in diameter. Traditional barens are handmade of many layers of paper bound in bamboo in Japan, where they are used in making woodblock prints; less expensive manufactured models are available in art supply stores.

The other option is to use an etching press to print your collagraph. The inked collage plate, covered with the printing paper and padded with felt printing blankets, is run between the press rollers at high pressure. The paper is thus pushed into the hollows of the plate to absorb ink and be imprinted with texture. The result is a completed collagraph, ready for drying and then displaying.

Collagraphy
TECHNIQUES

Once you have assembled the necessary materials

and equipment—a base, collage elements, glues, inks or paints, brayers, brushes, printing paper, and a printing press or barens—you can begin to compose your collagraph. Lay out the collage elements on the base, keeping in mind that the printed image will be reversed. If you have cut letters out of cardboard for text, for example, remember to apply them backward.

Before gluing any pieces into place, consider how the textures will transfer onto the print: a smooth element such as a Mylar sheet will not retain much ink on its surface after wiping, but ink will settle around its edges, thus defining its shape on the print; a string dipped into acrylic gel and placed on the base will create a line; partially raveled fabric (after it has been treated to make it nonporous) will print a fringed edge.

Choose collage elements that are not too thick; it is difficult to ensure a quality print when the paper has to be forced around items thicker than 1/16 inch. You may thin dense plant materials—cut flowers in half, or strip some of the leaves from a stalk (dried plant materials tend to hold their shape better; they must also be treated to make them nonporous). You may also make an impression of a thicker item, such as a key or an acorn—grease the item, coat one side with a paste or cement such as acrylic modeling paste, and then apply it to an absolutely flat sheet of paper (you might tape the paper down to ensure flatness as the paste dries). After several hours have passed, remove the item and cut off the excess paper. You may wish to use fine sandpaper to smooth the impression and reduce thick areas. Use the impression as you would any other collage element.

Next, treat any porous elements (paper, fabric, plant materials) to prevent them from absorbing ink. A thin application (on both sides) using a solution of water and acrylic medium will seal out moisture, allowing the surface to be coated with ink that will transfer its texture to the print. (Untreated material would absorb the ink like a sponge, printing an undefined blotch of color.) It is also possible to seal these elements after they have been glued to the base—just make sure the seal is complete.

Glue each collage element to the base, using glues that suit each material. You may also texture the base itself by cutting into it or by applying gesso or gels mixed with other materials (such as sand or crushed eggshells). After each element is glued into place, let the completed plate dry thoroughly. Clean off any nubs or thick streaks of glue or gel; otherwise they will show up on the print.

Next, prepare the colors. Though you may also use a brush or dauber to apply inks, a brayer is most typically used. Squeeze the colors onto a smooth palette, such as a Plexiglas sheet, to ensure that the brayer will be evenly coated. Tailor your choice of brayer and amount of ink to create the effect you desire. If you want all the surfaces of a built-up area to be inked, use a brayer with a soft roller and a liberal application of color. If you want only the topmost parts to print, use a brayer with a hard roller and less color. Textured surfaces that are left uncolored will emboss the paper as it rolls through the press; however, take care to protect these areas and other white spaces from trickles of ink. Wear cotton or plastic gloves to keep your hands clean.

For smooth, even color, inked areas should be wiped after the color is applied. Wiping with a cheesecloth produces a mottled effect that can help in blending colors. To effect a greater contrast between recessed and built-up sections of the plate, wipe with even strokes, using pieces of newsprint or even a block of wood; this removes ink from the top surfaces, yet leaves more in crevices and folds. You may need to repeat this process once or twice to distribute the ink or paint evenly. If, however, the color has been applied in a unique fashion, perhaps with brushes or in patterns not intended to cover a whole area, wiping may not be necessary.

Before printing, the paper must be cut to the correct size (leave at least a 2-inch margin on each side of the plate) and then dampened. This step removes sizing in the paper and softens it so that it can receive the imprint of the collage elements. Some papers must be soaked in a tray of water for a few hours; unsized papers may only need to be dipped quickly. Prepare the paper in advance, so that it is damp but not soaking wet at the time you will be ready to print. Handle the paper gently; it will be stronger after it has dried completely, but it can easily be torn when wet.

To prepare for printing, cover the inked plate with the paper, aligning it carefully so that there are even margins on each side (or you may prefer a wider margin on the bottom edge). Cover the paper with two or three felt printing blankets, which protect the paper as it passes through the press. You may wish to add foam padding to built-up areas on the plate to help it move smoothly through the press. It might be necessary to place a thin sheet of plastic between the paper and the blankets to protect them from glue or excess moisture. Then carefully run the print through the press. Some collagraph artists run a few proofs to fine-tune color, composition, and pressure.

You may instead use a baren to transfer the image to the paper. After placing the paper over the plate, rub the paper with the padded portion of the baren to obtain a smoothly transferred image. Using the edge of the baren will give a sharper outline. You can vary the pressure to create a range of effects.

Handle the completed print carefully. You may wish to touch up some details with color before drying the print. To dry it, sandwich it between several sheets of blotting paper, place these papers between sheets of newsprint, and then place all the papers between boards. Weight the boards with books or bricks, so that the print will dry flat, and replace the sheets of newsprint as they become wet. Keep the print weighted until it is entirely dry; then embellish it with lead or colored pencils, if you wish.

It is sometimes possible to create more than one print from a single collagraph plate. However, if the plate contains fragile items such as

8 Here the artist rolls the dampened sheet of printmaking paper over the plate, which combines inked collage elements and pieces that will be glued onto the print's surface. After the felt-printing blankets are placed over the paper, the printing process can begin. The scale of Berringer's prints requires a press with a 48-by-84-inch bed.

9 The artist checks the printed image at the press, to ensure that the applied papers have bonded well. She will re-glue any loose pieces. It is preferable to do re-gluing at this stage, rather than to apply too much glue to the papers before printing—since the glue may seep through the paper onto the felt blankets.

10 To dry the piece, Berringer places it between tissue papers and blotters; then it is pressed between boards for several days until it is dry.

11 After the drying is complete, Berringer enhances the print with pastels, graphite, and oil crayon.

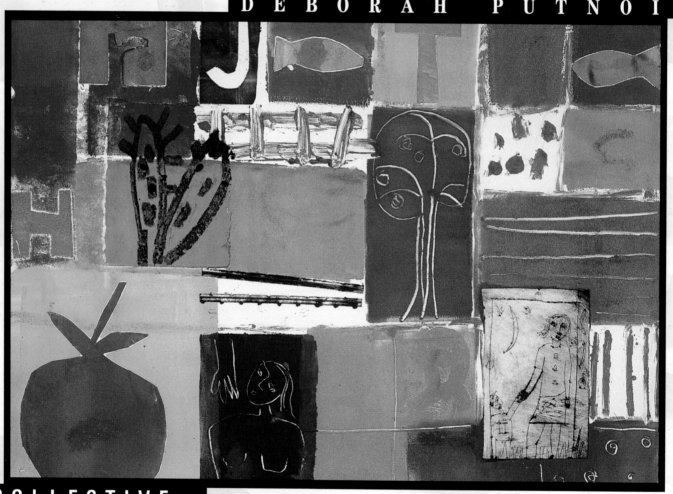

DEBORAH PUTNOI

COLLECTIVE Memory

Deborah Putnoi's world reflects her interest

in the themes of community and the way that collective memory is transmitted from generation to generation. She often employs imagery from everyday life, such as the human figure, domestic animals, playing children, and food. A sense of continuing dialogue is present in her work because of her frequent use of text and letters, her incorporation of pieces of her old work and old drypoint plates, and the way that one piece often suggests the themes of following works.

Putnoi rarely plans her pieces in advance. She works spontaneously, combining cutout shapes, applied papers, figures scratched into areas of paint, and ink drawings. She revises her work as she goes along, rearranging elements, drawing or painting over images, and trimming cut pieces to refine their shapes. She skips some of the traditional, methodical techniques of printmaking, such as sealing the plate and wiping areas of ink into place; instead, she prefers to work quickly and instinctively, allowing the random effects of the printing process to lend immediacy to her work. Putnoi's output is prolific, and she keeps a visual journal to provide inspiration and to generate new ideas.

Green apple + T
Monoprint
11" x 15" (28 cm x 38 cm)

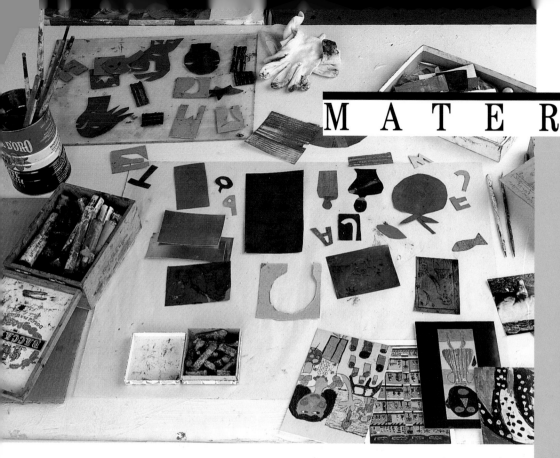

MATERIALS

utnoi uses a variety of materials in making her prints—her own used drypoint plates, remnants of her prints, cardboard cutouts, cloth, twist ties, flattened bottle caps—any odds and ends that are interesting in shape and texture.

assorted fabrics and papers

bamboo ink brush

blotter paper

brayers in different sizes

disposable gloves

etched aluminum drypoint plate

etching press

etching tools

X-Acto knife

Japanese calligraphy ink

mineral oil

oil paint in a variety of colors

paintbrushes

paper (such as Stonehenge)

palette knife

Plexiglas base

Plexiglas palette

PVA glue (such as Sobo Premium Craft & Fabric Glue)

scissors

thin cardboard with a finished side (such as Bristol board)

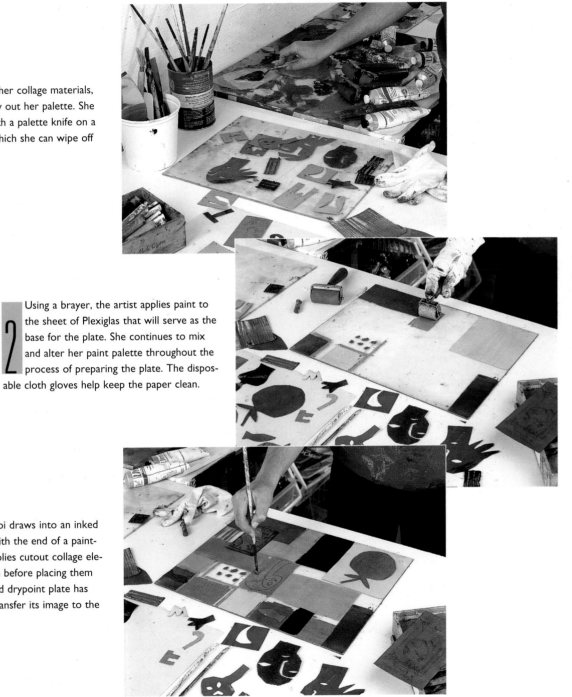

1 After she chooses her collage materials, Putnoi begins to lay out her palette. She mixes oil paints with a palette knife on a Plexiglas palette, which she can wipe off easily and reuse.

2 Using a brayer, the artist applies paint to the sheet of Plexiglas that will serve as the base for the plate. She continues to mix and alter her paint palette throughout the process of preparing the plate. The disposable cloth gloves help keep the paper clean.

3 At this stage, Putnoi draws into an inked area of the base with the end of a paintbrush. She also applies cutout collage elements, inking them before placing them on the base. An old drypoint plate has been freshly inked to transfer its image to the paper as well.

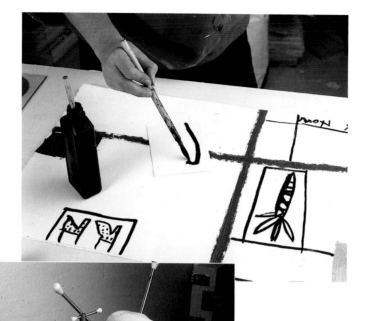

4 Putnoi often glues collage elements directly onto the clean printing paper prior to running it through the press. Here she is creating such a piece, using Japanese calligraphy ink and a bamboo brush. When this piece has dried, it will be glued onto the printing paper.

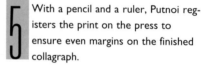

5 With a pencil and a ruler, Putnoi registers the print on the press to ensure even margins on the finished collagraph.

6 In the final step before printing, the artist has selected a piece of an old print to apply facedown on the plate. Glue on the side facing up will affix the piece to the printing paper as it passes through the press.

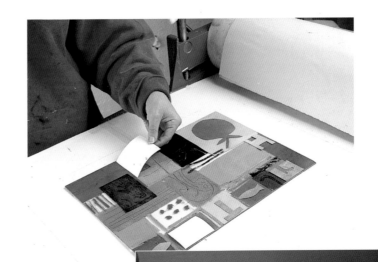

7 Putnoi runs the print through the press. In order for the image to transfer clearly, she has to run it through more than once.

Wet/Dry Technique

You might experiment with using both wet and dry paper for printing your collagraph, as Putnoi does. Dry paper can work well, provided that the collage elements are quite flat; a wet paper will absorb more ink and receive a clearer impression of textures and relief.

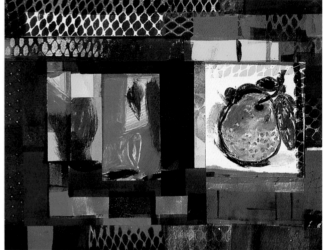

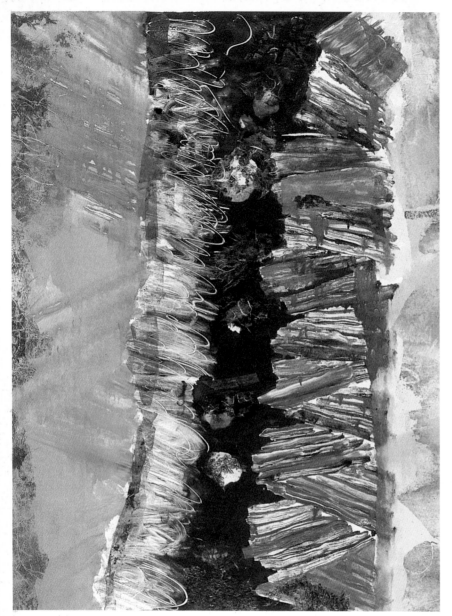

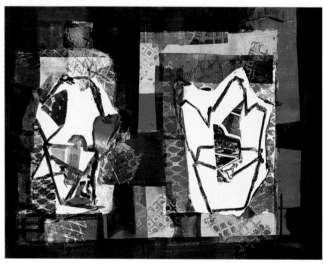

▲ **Diane Miller**
Noon Waterfall
Monotype collage
25" x 19" (64 cm x 48 cm)

GALLERY

▲ **Emily Myerow**
Chinese Take-Out #1
Monotype collage
14" x 18" (36 cm x 46 cm)

▼ Diane Miller
Waterfall IX
Monotype collage
25" x 19" (64 cm x 48 cm)

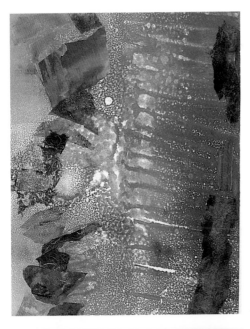

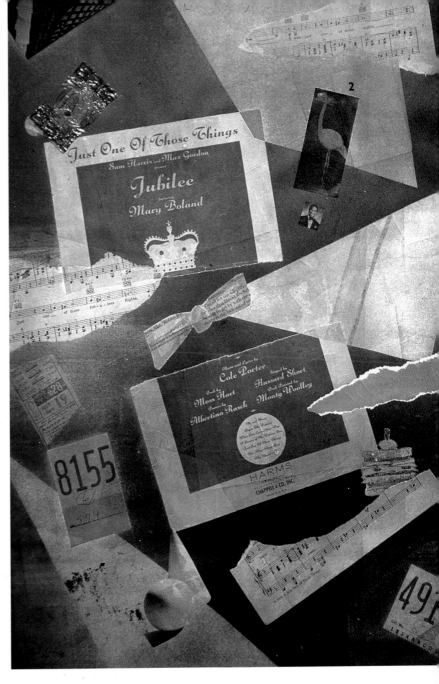

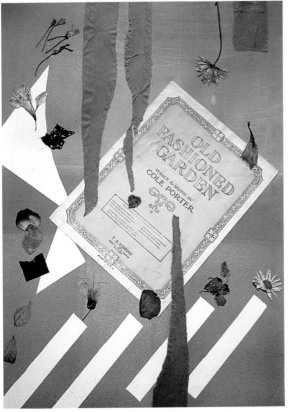

◄ Betty Guernsey
Old Fashioned Garden
Mixed media monoprint
30" x 20" (76 cm x 51 cm)

▲ Betty Guernsey
Jubilee
Mixed media monoprint
30" x 20" (76 cm x 51 cm)

◄ **Meryl Brater**
Pugillaris
Collagraph
28.5" x 90" (72 cm x 229 cm)
(detail, left)

▲ **Debra L. Arter**
Thoughts on Flight II
Collagraphy with unryu paper, stencil
resist, and *chine collé*
9.5" x 9.5" (24 cm x 24 cm)

◄ **Meryl Brater**
The Form of Language Book II
Collagraphy with drawing
8.5" x 6.5" (22 cm x 17 cm)

1 Freeman has had the photograph of the girl enlarged. Using contact cement, he has glued the enlargement to the plywood base. He applied the cement with a broad brush and then affixed the image to the plywood beginning at one edge, rolling out the photograph smoothly to leave no bubbles under the surface. Now he considers other elements that might complement the photograph.

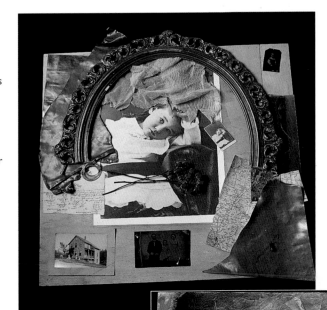

2 Next, Freeman works on enhancing the image with oil paints and graphite.

Using a Glue Brush
Using a broad brush to apply glue helps in making a quick, thorough application; none of the glue will begin to dry before the object is applied to the base, and the even application will help ensure a smooth surface.

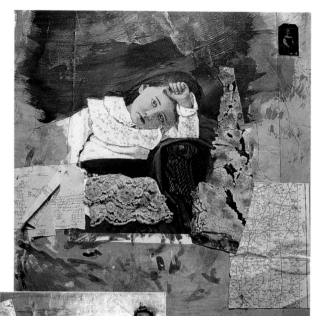

3 The artist narrows his choices of collage elements by juxtaposing them with the completed image of the girl. He considers adding fabric details, such as lace to enhance the dress. Freeman then attaches the paper pieces with gel medium and the three-dimensional pieces with contact cement.

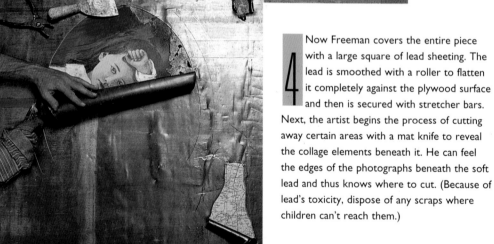

4 Now Freeman covers the entire piece with a large square of lead sheeting. The lead is smoothed with a roller to flatten it completely against the plywood surface and then is secured with stretcher bars. Next, the artist begins the process of cutting away certain areas with a mat knife to reveal the collage elements beneath it. He can feel the edges of the photographs beneath the soft lead and thus knows where to cut. (Because of lead's toxicity, dispose of any scraps where children can't reach them.)

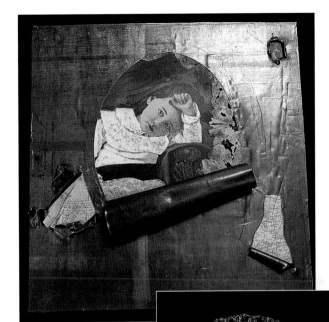

5 Freeman creates a neat, rolled-back edge to set off the photograph of the little girl and the swatch of the map. He uses a crinkled, irregular edge to reveal a part of the handwritten letter and the tiny photograph in the corner.

6 After the cutting of the lead sheet is finished, Freeman considers the placement of collage elements that will be affixed to the surface of the lead sheet. At this stage Freeman begins to apply the other surface objects—a tintype, a photograph, a bunch of dried roses sealed in acrylic medium, a fragment of sheer fabric, and part of an old frame.

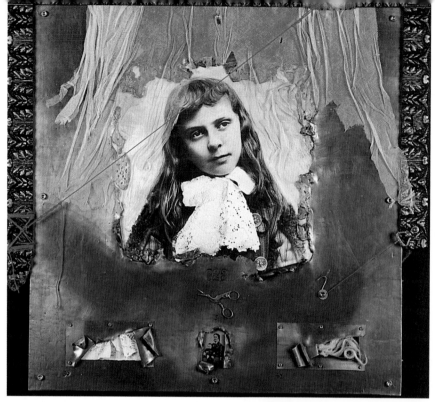

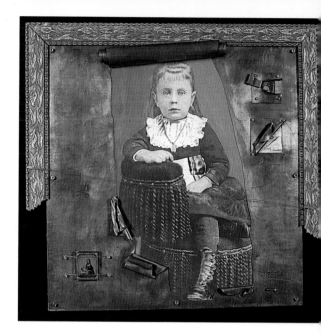

▲ **Ben Freeman**
Unfinished Works: Julie
Photograph, found objects on wood
36" x 36" (91 cm x 91 cm)

▲ **Ben Freeman**
Unfinished Works: Claire
Photograph, found objects on wood
36" x 36" (91 cm x 91 cm)

Douglas Bell ▶
Mermaid
Collage with oil, acrylic, and mixed
media on paper
9" x 7" (23 cm x 18 cm)

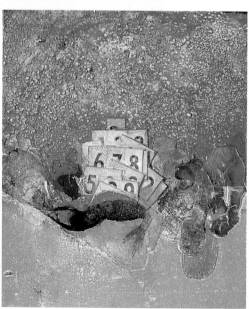

GALLERY

▲ **Nancy Rubens**
Handle with Care
18" x 14" (46 cm x 36 cm)

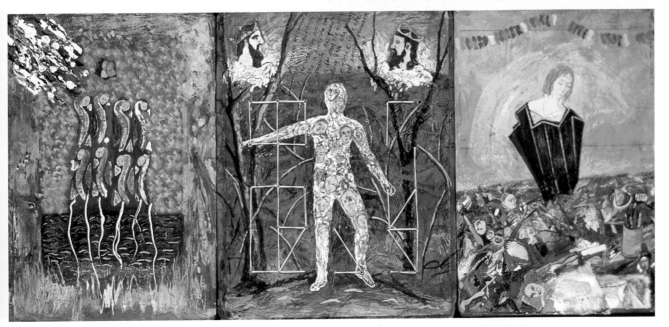

▲ **Francis Hamilton**
Dante
Collage with gouache
11" x 33" (28 cm x 84 cm)

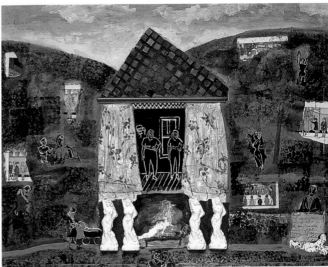

▲ **Francis Hamilton**
Everyday Fun
Collage with gouache, cast paper, wood
17.5" x 24" (44 cm x 61 cm)

◄ **William Harrington**
A Repro
Collage with mixed media
10" x 12" (25 cm x 30 cm)

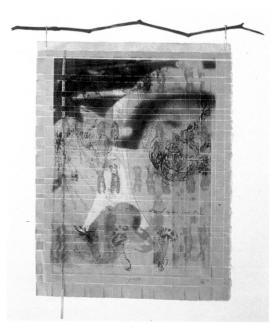

▲ **Lori A. Warner**
Untitled
Solvent transfer on woven oriental paper
8" x 6" (20 cm x 15 cm)

▲ **Ellen Wineberg**
Number 6
Monotype collage with woodcut on wood
28" x 29" (71 cm x 74 cm)

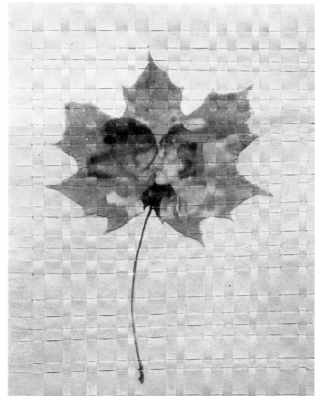

Lori A. Warner ▶
Epigenesis
Solvent transfer with silkscreen intaglio
on woven painted paper
14" x 11" (36 cm x 28 cm)

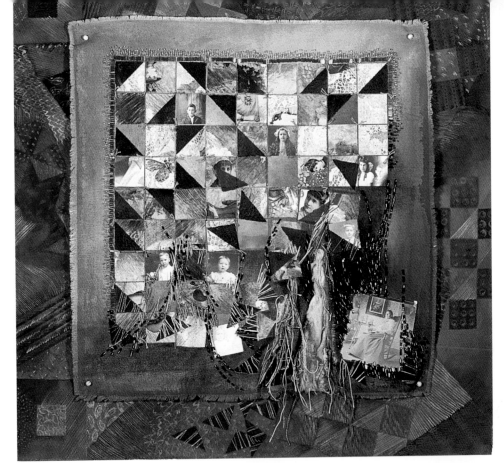

Janice Fassinger
Loss of Comfort
Collage with painted canvas, photographs, fiber, and beads
25" x 25" (64 cm x 64 cm)

Susan Hass
Ancient Runes
Collage with cyanotype, brownprint, plastic, wire, string, kozo paper, and handmade paper
44" x 29" (112 cm x 74 cm)

Susan Hass ▶
Collective Memory
Collage with alternative photo process
30" x 20" (76 x 51 cm)

133

▲ **Joyce Yesucevitz**
Remembrance
Collage with acrylic on linen
9" x 21" (23 cm x 53 cm)

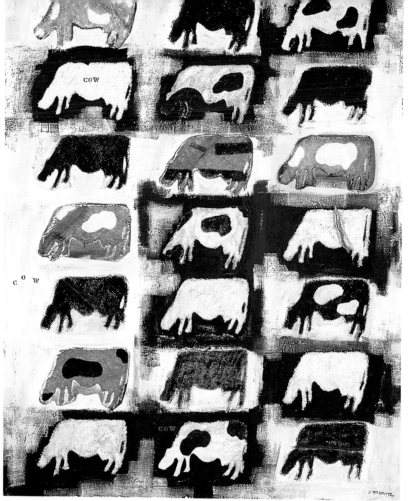

▲ **Joyce Yesucevitz**
Cows
Collage with acrylic and burlap on canvas
60" x 48" (152 cm x 122 cm)

▲ **Carole P. Kunstadt**
Funghi
Collage with mixed media
6" x 12" (15 cm x 30 cm)

Photo by Robert Kunstadt

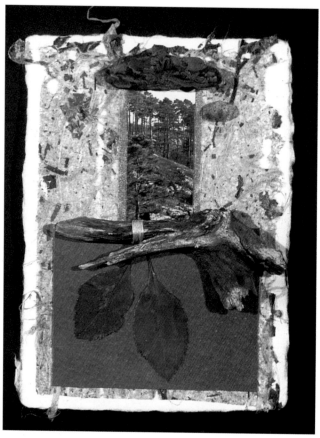

▲ **Carole P. Kunstadt**
Above Treeline
Collage with mixed media
8" x 6" (15 cm x 20 cm)

Photo by Robert Kunstadt

Deborah Putnoi
171 Fayerweather Street
Cambridge, MA 02138-1242
617-876-2006
or:
c/o Clark Gallery
P. O. Box 339
145 Lincoln Road
Lincoln, MA 01773

Deborah Putnoi attended Tufts University, Medford, Massachusetts, and the School of the Museum of Fine Arts, Boston, where she earned a BA in Political Science and BFA in Studio Art. She then attended the SMFA where she obtained her fifth year diploma in painting and printmaking. In 1990, Putnoi earned a Master of Education degree from the Harvard Graduate School of Education. She worked for a number of years at Harvard Project Zero where she did research on community art centers in economically disadvantaged communities and on museum education.

▼ **Deborah Putnoi**
green t and black j
Monoprint
11" x 15" (28 cm x 38 cm)

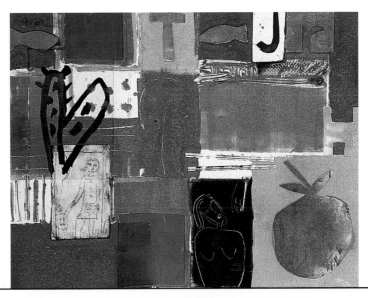

Clara Wainwright
57 Upland Road
Brookline, MA 02146
617-628-0060

Clara Wainwright is an artist with a strong commitment to community involvement, and has created community quilt projects with both adults and teenagers. She began working in fabric collage with little formal training. Born and raised in Boston, Wainwright studied literature at the University of North Carolina, and did not become interested in quilting until she was given a quilt when her son was born. She has created pillows, books, and community and youth quilts that have been exhibited in museums and university galleries throughout the Northeast.

Clara Wainwright ▶
Entrance to a Folly Cove Garden
Fabric collage
31" x 31" (79 cm x 79 cm)

EXPLORING CREATIVITY

THERE ARE A FEW THINGS ABOUT COLLAGE that are unique to it as an expressive medium. One of the most obvious—and gratifying to many—is that you don't have to be able to draw to make a good collage. (In fact, one of the most famous collage artists, Joseph Cornell, never learned to draw.) This isn't to say that many collage artists aren't also excellent draftspeople; a number of the artists in this book combine their work with painting and drawing to beautiful effect. But if you're self-conscious about your drawing skills—or maybe you don't have room in your house for a studio setup—it's great to know that there's a way to make art that can be as simple as tearing up an old magazine and pasting together the images to say something new.

Artistry in collage can have multiple moments of inspiration. One of these has to do with creative collecting. Quite different from collecting baseball cards or McCoy vases, creative collecting is the searching out of interesting objects for possible use in making art. "Broken Melody" (page 145) by Judi Riesch is a perfect example of what can result when a collector has an eye for the latent magic of castoffs. The focal point of her assembled piece is a vintage photo album she unearthed at a flea market. What made the album remarkable to Riesch is that it contained a music box inside its cover, so she exposed the guts and embellished them with strung wire and wax drippings to draw attention to their distinctiveness. Though as an album the item had outlived its usefulness, Riesch recognized the beauty

inherent in the object and created an artwork around it, giving it new meaning and worth.

What Riesch experienced when she saw the album's potential is a moment of recognition that is another example of the creative inspiration fundamental to collage making. Whether wandering through a flea market or just sifting through boxes of collected ephemera while working, the artist will suddenly see an item as right—the right shape, the right statement, the right fit. Deborah Putnoi's work depends on her ability to make these recognitions. For "Enmeshed" (page 154), she let the materials inspire her, using items as diverse as pieces of embroidery, etched metal plates, and torn up drawings made specifically to use as collage elements. Working within a grid structure, she moved around the various elements and layered some sections with paint until she found a composition that worked. Her process is an intuitive one, developed over years of working as an artist. Open-ended meanings, multiple statements, and surprising combinations are all part of the creative mix in her work that makes it so evocative.

When a collage is finished, a transformation has occurred: Where there once was a random collection of found or created objects and images, there is now a cohesive whole. This creation is something more than the sum of its disparate parts and is able to express a theme or meaning that none of its components conveys alone. Chantale Légaré's "Crossings" (page 151) is a house-

⊚⊚ BROKEN MELODY ⊚⊚

Like many collage artists, Judi Riesch often finds inspiration in a single object. Here, it was the discarded back of a vintage music-box photo album she discovered at a flea market. She found its mechanical inner workings unusual and beautiful, and decided to create a loose narrative inside the album using an old photograph, antique textile fragments, and words and numbers cut from vintage papers. To house the album, she created an intimate interior space by collaging a shadow box frame with vintage ledger pages and sheet music. A decorative gold frame lends the piece a Victorian feel, yet her use of wire embellishments and beeswax drippings is distinctively modern.

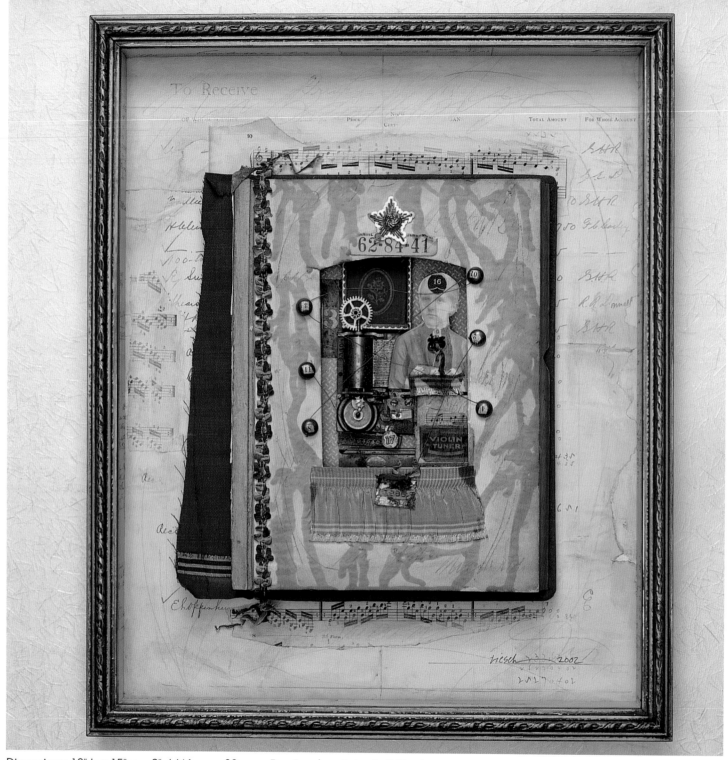

Dimensions: 18" h × 15" w × 2" d (46 cm × 38 cm × 5 cm) | Artist: Judi Riesch

eccentric. I search out the uninvited marks or disturbing color to see how that will add an element of surprise to the composition. As Shaun McNiff says in his book *Trust the Process: An Artist's Guide to Letting Go*, "In the creative process, one action leads to another, and the final outcome is shaped by a chain of expressions that could never be planned in advance." Openness to mistakes, mess, chaos, and the unknown all allow the process to flow and unfold.

At the same time, discipline is essential. Having an idea that you would like to make something is only the first step. Getting in there and doing it, and continuing to do it, is almost the most important aspect of creativity. It's about going to the "office"—be it the studio, the cafe, the outdoors—and working. For me, at times, this is the hardest part of being an artist. It is difficult to face work that is not progressing and there are times I just don't "feel" creative. But the discipline of holding to a set studio time, of going there and making something (anything), is important in keeping the creative process dynamic.

Finally, involvement in the creative process requires passion for the whole endeavor. I need to rip paper and collage the torn shreds onto a white canvas. I need to feel the paint sliding over the textured surface, to thrust my brush into the heart of the composition. I crave the feeling of my materials. I love to mix colors and watch the subtle ways they can change by just the slightest addition or subtraction of another color. I had a teacher at art school who said to a fellow student, "If it is a choice to paint, then don't choose it. Painting chooses you—it is an inexplicable need."

For each person the creative process is a unique exploration. Each of us has an individual fingerprint and the way we work in expressing ourselves is also singular. As I place the final element into the composition, I step back and look at the piece as a whole. I start to make connections among the shapes and forms, and in my mind's eye I glimpse another way the work could be resolved. I grab another canvas, pick up an old drawing and cut out a section, collage it onto the surface, and I am off creating the next piece—one in a chain of pieces that I make as an outgrowth of the creative process, which is central to my existence.

⊚ CHRONICLING ⊚ RELATIONSHIPS

THE CONNECTIONS BETWEEN and among people, and between people and the world they live in, are the subject of the following chapter. With these projects, the artists seek to honor special relationships in their lives and to divine the meaning of connectedness and relating. Projects range from personal portraits of a specific loved one to overviews of how identity is affected by the societal rules and expectations that shape human relations.

Although the personal nature of some of these works makes them seemingly less accessible to the viewer, who likely will not know particular details, their atmosphere of intimacy serves to draw the viewer in, allowing a more intuitive understanding to occur. In "The Chess Lesson" (page 166), Paula Grasdal put together an affectionate portrait of her father that reflects his love of his profession—teaching math and physics—and of chess. Because we know the game requires two players, the presence of the artist is implied as that second player, the recipient of the lesson. Encountering the board head on, the viewer experiences the piece from the artist's perspective, that is, "across the chess board" from the father. And even though the youthful man looking back at us is a stranger, we experience him in the role of father by bringing our own memories and feelings about our fathers to the piece. In this way, a particularly private vision becomes universally accessible.

While some artists choose a subtly implied presence (or aren't present at all) in their collages, many others successfully place themselves inside a piece, granting further insight into the story of a relationship by spelling out their place within it. Maria G. Keehan uses a photograph of herself looking up at representations of memories and stories about her grandmothers, in "What I Think I Know About Elizabeth and Maggie" (page 169), to show how she is seeking to know them and how half of her comes from each of them. Meredith Hamilton ("Le Mariage," page 172) uses an image of herself as a princess bride (a playful nod to notions of fairytale romance) on top of a wedding cake carousel, which represents relationships as filtered through the lens of marriage. Her knight wears shining armor with a twist: He sports a literal "blockhead."

Taking on the theme of a relationship to a place rather than a person, Grasdal's "Pond Life" (page 160) honors an island along the Pacific Northwest Coast where she spent time as a child. Nestling a portrait of lily pads among repeated images of the pond's lush surface and encasing the whole in layers of colorful encaustic paints, the artist built an abstraction of water and plant life that evokes rather than re-creates the actual pond. The only visitor is a dragonfly, hovering in place over the blue water. A symbol of regeneration and change, the dragonfly represents the biological cycles in the real pond and also changes to the pond as it exists in the memory of the artist.

Objects and images within an assemblage or collage can carry meanings according to where they are positioned in

Samsung Color Laser Printer
CLP-360 Series

a piece. Hamilton's wedding cake collage uses the tiers of the cake to establish a social structure wherein the married couple is the center, their children are the second tier, and friends, career, financial decisions, and home make up the final group of forces at play in the couple's life. Another artist's collage of the same subject could look very different if, for example, there were no children and so career or friends played a larger role. In Keehan's piece, the placement of images and objects hints at discrete narratives within the whole: At the center of each half is the grandmother whose life is featured; the background is their actual "background" (photos of their birthplace); and surrounding details tell of journeys (a ship at sea, a map of destinations, parts of a diary) and religious faith (a rosary, an image of the Virgin Mary).

The choices you make about how to approach your subject will greatly affect the outcome, so take time when you're getting started to think about what you want to say. When working on a place collage, think about what aspects of the place are most meaningful to you. Consider various times of day and photographs taken under different weather conditions. What mood do they establish? Which ones best represent how you feel about the place?

If people are a part of the appeal, include them. Grasdal focused on a pond in her place collage, but Bowen Island also has beautiful forests and beaches she could have highlighted for dramatically different results. A series of three or four collages could show the island's varied topography and offers an interesting alternative approach.

When chronicling a relationship with a person, consider it from a variety of angles: Do you want to portray a relationship as it is (or was) or an idealized vision of what you wish for it? What details and images will offer insight into the personalities of the people in your collage? And where are you—a part of the story or, like the viewer, outside of it? The key is to follow your instincts, letting the collage develop with each new addition or change. And nothing says you have to focus outward: A relationship collage can also offer a way to examine aspects of your own personality and life, allowing you to explore your relationship to yourself. Whatever your approach, as you are positioning images, textures, and objects in layer after layer, you'll find yourself engaged in an intuitive process that may begin with a specific idea but will undoubtedly lead to a discovery of much more.

❧❧ POND LIFE ❧❧

This lushly hued piece, encaustic and collage on
plywood, celebrates the artist's relationship to a
special place—Bowen Island, located on the
Pacific Northwest Coast. Recalling childhood
explorations of the island's natural wonders,
Paula Grasdal focused on images of a pond,
carpeted with lily pads and whirring with
iridescent dragonflies. The combined elements
of photocopied photographs, incised drawing,
and translucent wax create a tactile layered effect
characteristic of the encaustic technique.
The repeated lily pad image and the translucent
blues and greens of the encaustic paints lend the
piece tranquility, evoking thoughts of quiet
contemplation and feeling connected to the
natural world.

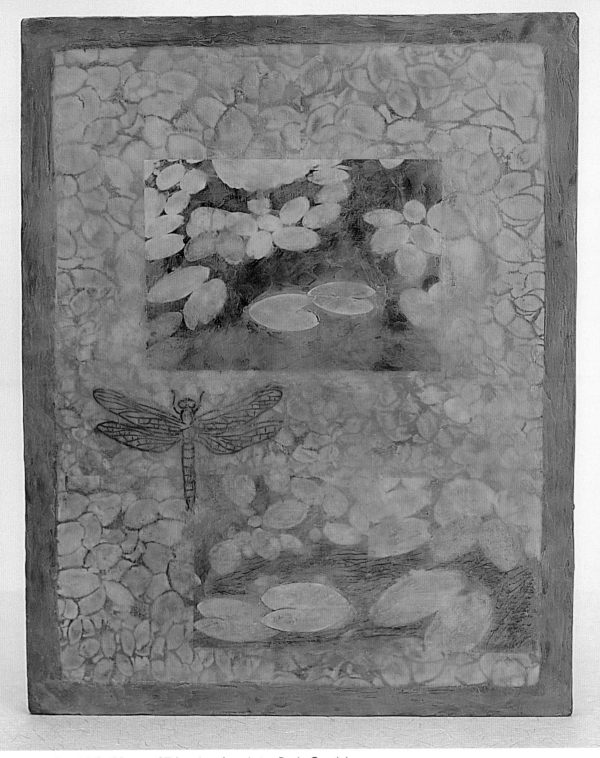

Dimensions: 13" × 10³/₄" (33 cm × 27¹/₂ cm) | Artist: Paula Grasdal

POND LIFE ◉

STEPS

1. To begin this project, read about encaustic technique on page 175. Make multiple photocopies of various photographs of a place that is meaningful to you. Enlarge or shrink them to vary the composition. To create the background design, arrange the photocopies in a repeat pattern on plywood and trim them to fit. Glue the background papers in place with PVA, roll with a brayer, and let dry. Reserve the main image for use in Step 3.

2. Paint a layer of hot encaustic medium over the collaged papers and the board's edges. Blend pre-mixed encaustic colors with encaustic medium for a translucent effect, and paint the tinted wax onto the first wax layer. Fuse the layers together with a heat gun.

3. Apply the main image by heating a section of the wax background with a heat gun and pressing the paper onto this heated area. Encapsulate the paper by painting hot wax medium over its surface. Fuse with a heat gun.

4. Cut out selected shapes from your photocopies (the artist chose lily pads) and collage these on top of the main image and elsewhere on the composition, using the same method as in Step 3. You can also use pressed leaves, old letters, maps, etc. Engrave an image with a stylus into the wax (such as the dragonfly) and rub an oil pastel over the incised lines. Wipe away the excess pastel with a linseed-oil-soaked cloth.

5. Create a border by painting opaque wax in a contrasting color around the board's edges and sides. Fuse with a heat gun and let cool. To create a surface sheen, polish the wax with a soft cloth.

TIPS

Wax is not compatible with acrylics (including acrylic gesso) but can be combined or layered with oil paints and oil sticks. To clean your brushes, dip them in a tin of hot paraffin and wipe the bristles with paper towels.

MATERIALS

- ◉ black-and-white or color photocopies of photographs
- ◉ piece of 3/4" (2 cm) plywood for backing
- ◉ oil pastels
- ◉ linseed oil
- ◉ encaustic paints and medium
- ◉ heated palette (for heating wax)
- ◉ heat gun with variable speeds
- ◉ natural bristle brushes
- ◉ stylus
- ◉ adhesive: PVA glue
- ◉ basic collage supplies (see page 12)

❧ 4 DRESSES ❧

Dresses are metaphorically laden with meaning about feminine identity, from issues related to physical appearance to expectations about women's roles and relationships. To suggest how societal forces shape women from childhood onward, Jane Maxwell uses a repeated paper doll-dress form as her central image. She manipulates the images with colorful vellums and photocopied imagery, then layers them over various found papers such as texts, sewing patterns, and printed images. Despite the rigorousness of the dress form and its insistence on conformity, individual "personalities" are visible through the vellum and successfully subvert the form.

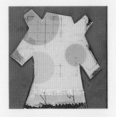

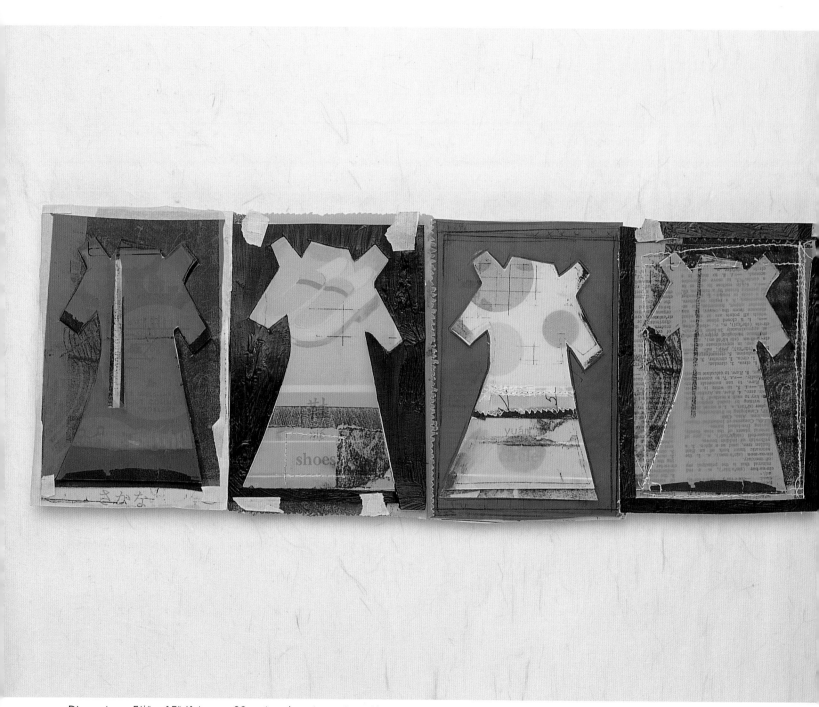

Dimensions: 5½" × 15" (14 cm × 38 cm) | Artist: Jane Maxwell

4 DRESSES ☺

1. Select imagery from a variety of sources—magazines, books, found papers. Seek out imagery that relates to an overall message, for example, "4 Dresses" features writing from sewing patterns and related circle imagery, representing the whole person beneath the cutout form.

2. Photocopy chosen images onto vellum in various colors. Play around with varying image size, using color and black-and-white copies, and combining or layering images right on the copy machine. Another good layering material is clear acetate, which photocopies well and offers a slick contrasting texture.

3. Find a central image to repeat (in this case, an actual doll-dress form) or create your own. Choose something that speaks to you—a tree, a window, a tiara. Repeated imagery will have impact in a line of two, three, or four, and also two over two.

4. Build repeating forms by layering found papers under and over the central image and by utilizing negative spaces. Create dimension and contrast with acrylic paint or charcoal.

5. Join the repeated images using a variety of binding materials (tape, stitching, glue). Be creative: Household items such as straight pins, masking tape, and staples add texture and interest.

MATERIALS

- ☺ vellum, clear and assorted colors
- ☺ background imagery from books, postcards, sewing patterns
- ☺ photocopies of various images
- ☺ acrylic paints
- ☺ charcoal pencil
- ☺ thread and sewing machine
- ☺ adhesive: PVA glue
- ☺ basic collage supplies (see page 12)

☺ Jane Maxwell's Creativity Tips

Don't limit yourself to solid colored papers: Transparent vellum and acetate papers are also available in a variety of patterns and become high-impact layering pieces when transformed by a photocopied image. Another tip: Take a preexisting piece of your art, place it on a copy machine, and transfer it onto a variety of papers. It's a great starting point for future pieces. And keep your eyes open for unique paper and images. Flea markets and antiques malls are great for digging up vintage signs, posters, books, ledgers, etc. Old papers have a special color and textural quality that adds depth, richness, and history to a collage.

‌‌ THE CHESS LESSON ‌‌

This richly colored fabric collage pays homage to the artist's father, a physics and math teacher and an avid chess player. Paula Grasdal used photo transfer techniques to create the portrait of her father as a young man and the silhouettes of chess pieces. Transferred images of physics equations evoke a classroom blackboard and together with pieces of metallic mesh build a containing border for the chessboard. The board's grid pattern organizes the disparate elements of the piece and also reflects her father's logical and thoughtful approach to life.

WHAT I THINK I KNOW ABOUT ELIZABETH AND MAGGIE ☺

STEPS

1. Find a suitable container: an old silverware case, wooden cigar box, painted metal tin. Clean up the insides and paint with gold-leaf paint. Cover hot-press illustration board with marbleized or other paper and glue it into the back of your box.

2. Assemble photographs and found images. Choose a portrait and have an iris print or color photocopy made to size. Using acrylic medium, mount it on Bristol board backed with gold tissue paper. Cut out with a craft knife.

3. If you can, use a computer to alter photographs in creative ways. The artist downloaded images to Photoshop, played with them, and embellished printouts with colored pencils. She also colorized black-and-white images (of Rudolph Valentino) and created strips of small headshots of her grandmothers. Many of these effects can be reproduced manually with the help of a color photocopier.

4. Do research to find out things, such as what the town where your person was born was like and other historical facts that relate to their life, or rely on your memories alone. Copy passages from their favorite book. If possible, obtain photocopies from diaries or letters in their handwriting.

5. Assemble all of your materials (including relevant found objects) and play with arrangements in the box. Glue things down slowly, considering the composition as you work. Let pieces relate to each other to create a narrative about the person or relationship you're commemorating. Draw attention to details through interesting placement (such as the ship in the corner seen here), juxtaposition, and repetition.

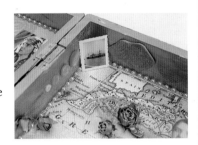

MATERIALS

- ☺ case to house collage
- ☺ color printouts or photocopies of photographs and diary entries
- ☺ iris prints (high-end digital prints; color photocopies may be substituted)
- ☺ found objects and embellishments such as buttons, stamps, stones, rosary beads, old photographs
- ☺ decorative papers such as embossed tissue paper, gold tissue paper, marbleized paper
- ☺ gold-leaf paint
- ☺ colored pencil
- ☺ Bristol board and hot-press illustration board
- ☺ heavyweight rag paper
- ☺ sandpaper
- ☺ brass hinges
- ☺ friend with digital camera
- ☺ adhesives: acrylic matte medium, craft glue, wood glue
- ☺ basic collage supplies (see page 12)

⊚⊚ LE MARIAGE ⊚⊚

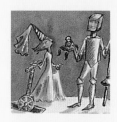

The conceit Meredith Hamilton created for this watercolor-based collage about marriage is a wedding cake carousel—a traditional symbol of romantic love reconfigured to reflect the realities of life, where relationships are anything but static. To build the piece, she first inked, then collaged and painted on top of handmade paper to create a unified cake shape. Next, she added stamps, images from vintage books and cards, smaller watercolors and drawings, and money fragments. The origins of the merry-go-round lie in the Crusades, and the name "carrousel" originally meant "mini war" in French. Hamilton posits that marriage, too, is a kind of mini war, with many competing forces at play. Open "doors" in the cake reveal the mechanism that powers the carousel, and the bride's hand (the hand of the artist) holds the control.

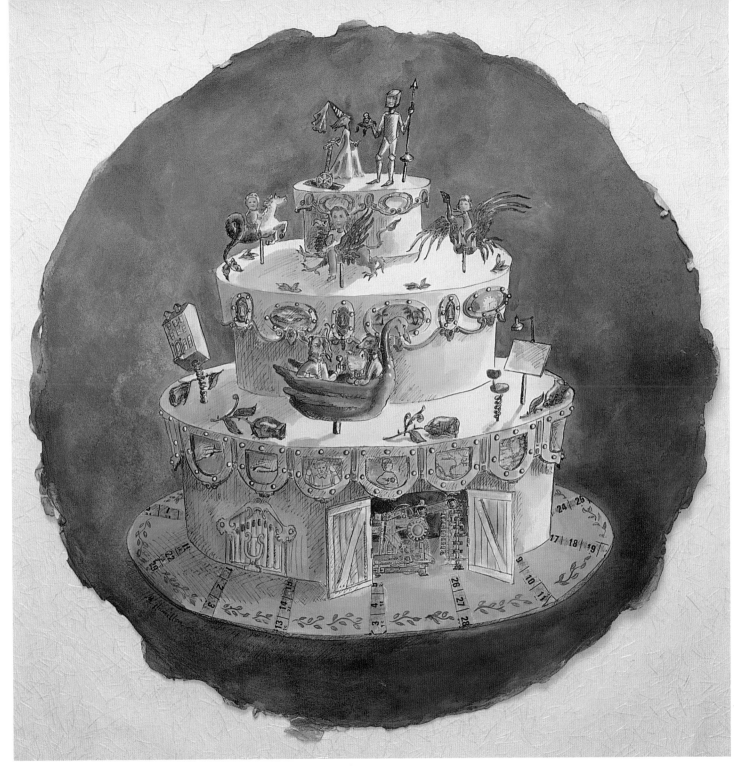

Dimensions: 19" in diameter (48 cm) | Artist: Meredith Hamilton

LE MARIAGE ☉

STEPS	**MATERIALS**

STEPS

1. Paint or draw an unadorned wedding cake. This will be the foundation of your collage, whether you fill it using painting and collage as the artist has done or by collaging on cutout images. Decorate the cake with washes of paint, colorful paper, found or created images, rhinestones, ribbons—whatever works for you. (The artist used pieces of maps and roses made of the leafy drawings on money.)

2. The top layer: If you are making the collage to represent your own marriage, find or make a representation of yourself and your partner. (If you aren't married, rework the image to reflect other important relationships.) This piece is topped with a bridal couple. The groom's head is a drawing of a "blockhead," a wry comment by the artist on the stolid way her husband sometimes relates to people. The bride's face is George Washington's face cut from a U.S. dollar bill and represents financial considerations in life.

3. Layer two contains a second tier of forces, in this case, children. Again, choose whatever is relevant to you—children, friends, career—and find or make appropriate images. The artist has depicted her children riding carousel animals that mirror their personalities: a phoenix, a griffin, and a Pegasus-fish. Their faces are cutout images from Victorian cards.

4. The third tier of the cake is for other significant forces or events: the purchase of a house (shown on a spring, bouncing crazily); friends (represented by animals partying in a swan boat); and career (the artist's desk, looking blank because there's never enough time for art). Alter and embellish your images in creative ways as the artist has done, to show how you feel about these elements in your life.

MATERIALS

- ☉ heavy paper for base (the artist used a handmade paper by Twinrocker)
- ☉ interesting found papers such as money fragments, old stamps, images from old books and maps
- ☉ drawings or photographs of people in your life or representations of those people (from magazines, books, vintage cards)
- ☉ watercolors
- ☉ adhesive: PVA glue
- ☉ basic collage supplies (see page 12)

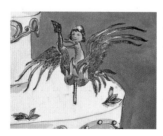
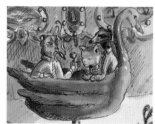
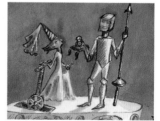

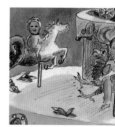

ENCAUSTIC COLLAGE

PAULA GRASDAL

Encaustic is an ancient technique of painting with pigmented hot wax that produces a luminous and tactile surface. Encaustic paint has three main ingredients: purified beeswax, damar resin (a natural tree resin), and pigment. Encaustic medium, which is beeswax mixed with damar, produces translucent glazes when mixed with the pigmented wax. Encaustic can be cast, carved, scraped, scratched, and embedded with collage materials to produce a wide variety of intriguing results.

Recent availability of premixed encaustic paints and medium has inspired the reemergence of this versatile medium. Artists such as Lynne Perrella (page 181), Tracy Spadafora (page 244), and Cynthia Winika (page 248) incorporate collage elements into their encaustic paintings to great effect. The warm wax acts like an adhesive, and the artist simply encapsulates the absorbent collage materials in the wax. Paper, fabric, photos, leaves, gold leaf, and thread are just a few of the many suitable materials.

BASIC TECHNIQUES

Encaustic technique can be broken down into three basic elements: heating the pigmented wax on a hot palette, painting the hot wax onto an absorbent surface, and fusing each layer with a heat source. For heating the wax, place various colors in small tins on a hot palette (this can be purchased from R&F Handmade Paints or improvised using a Teflon griddle on a hot plate; see Product Resource Guide, page 267) and heat to no more than 220°F (104°C). Using natural bristle brushes (synthetic ones will melt), blend the colors on the hot palette and paint onto the support. Any absorbent surface—a braced wooden panel, watercolor paper, plaster, or "clayboard"—is suitable as a support for wax. Fuse each layer by reheating the wax with a heat gun or tacking iron (this step is important as wax tends to separate into discrete layers). Ventilate well with an exhaust fan next to your work surface as overheated wax fumes can be toxic. If your wax starts smoking, it is too hot—turn down the heat on your palette even if the temperature gauge is at 220°F (104°C).

COLLAGING WITH WAX

Layering delicate paper and wax creates a subtle effect of floating textures and images. Try drawing on translucent rice paper with oil pastel and then embedding it in wax: The paper will seem to disappear, leaving the drawing suspended. Many layers of wax and paper can be added to create a rich surface with lots of depth. Another technique is to cover the support with collage material before adding the encaustic.

EXTENDING THE PROCESS

There are many methods of working with encaustic; here are a few ideas for inspiration. Images can be transferred onto the wax at any stage in the layering process (and no solvents are necessary). Simply place a photocopy of an image face down on cool wax and burnish it with a bone folder. Peel off the paper to reveal a reversed image on the wax. Gilding can be added as a final stage by simply burnishing the metallic leaf with a cotton ball. To embed a line drawing in the surface, incise the wax with a stylus, rub an oil pastel into the lines, and remove excess pastel to reveal the markings. Finally, for an antique effect, layer contrasting encaustic paints on top of each other and, like an archeologist, scrape into the surface to reveal the underlying colors.

For more information on encaustic, see *The Art of Encaustic Painting* by Joanne Mattera.

⊚ EXPRESSING ⊚
DREAMS AND WISHES

There's something about the nature of collage—the juxtaposing of images, the playing with scale, the use of photographically realistic depictions—that has the quality of being both real and unreal at the same time. This in part explains its popularity among the Surrealist artists of the 1930s and 1940s, whose groundbreaking works are the most widely known examples of fine art collage. It also explains why the medium lends itself so well to the exploration of dreams—not just the expression of dreamlike narratives, but the articulation of an artist's wishes and desires. The artists in this chapter do a little of both, and their creations range from concentrated works focused on a single theme to dynamic pieces whose many parts evoke myriad interconnected meanings.

In "Transformation" (page 184), Paula Grasdal explores the theme of change and mutability as expressed through the image of a butterfly, surrounded by sinuous green vines and placed against a patch of vivid sky. Abstract in the manner of a dream, in which a butterfly represents the dreamer, this evocative piece celebrates the transformative possibilities inherent in any significant life change. It also shows us that collages don't have to spell things out to effectively get their meaning across. When you're thinking about how to begin a project, be open to thematic approaches rather than getting bogged down in specific narrative details. As the modernists used to say, sometimes less truly is more.

A project that successfully waxes specific, Kathy Cano-Murillo's "World Traveler's Dream Mobile" (page 193) is a fanciful construction made of ordinary materials: CDs, paper, dowels, ribbon, and beads. A kinetic presentation of twelve miniature collages, each of which represents a country the artist would like to travel to, this intricate mobile embodies the inquisitive energy of the dreamer who wishes to explore the unknown. Pictures of elephants, dancers, drinks, and dragons decorate the vibrant disc surfaces, joining together multiple fantasies about adventure and travel. Another interesting aspect to this piece is that because it is a mobile, it actually moves—a further way to underline the fact that it is about travel and moving around in the world.

In a slightly more surreal vein, Olivia Thomas conjured up a magical doll (page 178) that houses dreams and wishes. With a body made of artfully appliquéd and painted fabric, a photo transfer face (from a vintage photograph), and crochet-hook arms, the doll seems like an amalgamation of the aesthetics of different eras. She carries simple objects in her belly—a key, a heart, coins, and dice—that symbolize her inner desires for wisdom, love, prosperity, and luck. (When making a project like this, choose objects that have special meaning, as they will add potency to the wish.) The dreamy effect of the painted fabric surface makes an effective visual foil to the everyday nature of the found objects, creating a context in which it is easy to believe in their talisman-like powers. Because of

the ease with which real items can be incorporated into collages, artists can take advantage of the evocative powers of those objects to create shrine-like artworks in which everyday things can symbolize more complex desires for happiness, artistic fulfillment, or love.

Making use of a range of surrealist effects, Holly Harrison's "Dream House" (page 190) depicts specific wishes and desires for a happy life through a whimsical representation of an ideal house. Liberally sprinkling the picture with under- and oversize images, the artist shows a bird making its nest atop a red house, which has several windows open to reveal specific desires: romance, artistic friends, and fabulous shoes. The smoke curling from the chimney is computer-manipulated sheet music, while (in a nod to René Magritte) silver folk art stars sparkle in a daytime sky. Happy flowers wear human faces, a map of New York covers the roof, and game pieces mark the path to the front door. The key to making a piece like this is that there are no rules—follow your imagination wherever it leads. Just as dream logic creates fantastical scenarios

and disjointed narratives, so does this collage explore the desires of the mind and heart through impossible scale, quirky juxtapositions, and playfully altered imagery.

As demonstrated by the range of projects not just in this chapter but in the book as a whole, collage is an extremely flexible medium. And because it requires an intuitive approach—piecing things together that seem to fit, finding a composition that "feels right"—there are almost no limits to what you might discover or say. As you move your collage elements around on a surface, you'll find that some images seem to "speak" to each other while others retreat into the background, letting themselves be obscured by veils of paint or paper only to assert themselves in the finished product as secret meanings or partially revealed truths. In the same way that a dreamer moves through a dream, piecing together disparate elements until a kind of narrative is born, so does the artist travel through the making of a collage, without fully knowing where he or she is going but confident in the merits of the journey.

⚏ ART DOLL ⚏

*Combining found objects with fabric collage,
stamping, and photo transfer techniques,
Olivia Thomas has shaped a whimsical
personification of her hopes and dreams: A red
and yellow doll with burning desires caged in her
belly, held in place by a simple mesh screen.
By embellishing layers of patterned fabric with
buttons, beads, and wire, Thomas has created a
rich, tactile surface filled with personal symbols.
She also plays with scale and visual contrasts,
combining a vintage photograph face and wiry
crochet-hook arms with a rectangular body to
produce a surrealistic effect.*

SHHH ... ⊚

STEPS	MATERIALS

STEPS

1. Stain an unfinished shadow box walnut, and antique it using soft white acrylic paint, moss green glaze, and tinted finishing wax (to seal). Once dry, sand along the edges to expose stain.

2. To make the glass tile: Scan a photo of a butterfly. In Photoshop, convert the image to CMYK and separate the channels into four images that will print in each color. Print onto transparency paper. (Alternatively, use a color photocopier to approximate the effect.) Trim to 3" (8 cm) squares, remove the cyan, and sandwich the remaining images between the three glass squares with the black and magenta together and the yellow on its own. Wrap with adhesive copper tape.

3. To make the front panels: Cut two 3¼" × 8" (8½ cm × 20 cm) panels of basswood. Use glue and collage medium to attach decorative papers, pressed flowers, and photocopies to the panels. Stain the papers with tea, and mottle with moss green glaze. To secure the butterfly tile, use brass escutcheon pins (aged in darkening solution). To attach the hollow egg, use a hot-glue gun.

4. To make the see-through panel: Using wire cutters, trim a 4" × 8" (10 cm x 20 cm) piece of hardware cloth. Print a photo on vellum (use a laser printer) and collage it onto the hardware cloth. Let dry. Print a color scan of a flower or other image on transparency paper. Trim to size and staple it to the wire frame.

5. To make the SHHH panel: Cut a 4" × 8" (10 cm × 20 cm) panel of basswood. Print a photo on vellum and collage it onto the panel. Let dry. Stamp letters using the wooden type and sepia calligraphy ink. Wrap hardware cloth or other embellishment around the bottom.

6. Assembling: Paint the ¼" × ¼" (½ cm × ½ cm) basswood strips with soft white acrylic paint and cut into eight 8" (20 cm) lengths. Glue into the box to create runners at top and bottom, incorporating the panels as you go and leaving room for them to slide. The two back panels share the same runners. Add the type if desired (as shown).

MATERIALS

- ⊚ 8" × 10" (20 cm × 25 cm) shadow box
- ⊚ two 4" × 24" (10 cm × 61 cm) basswood panels, ¼" (½ cm) thick
- ⊚ three ¼" × ¼" (½ cm × ½ cm) basswood strips, 24" (61 cm) long
- ⊚ wooden type to spell a word or sound
- ⊚ embellishments such as a speckled egg, pressed flowers, photographs
- ⊚ assorted papers (the artist used wall paper, transparency paper, cream vellum, natural bark paper, and acid-free tissue paper)
- ⊚ hardware cloth
- ⊚ three 3" (8 cm) squares of glass, 1/16" (⅛ cm) thick
- ⊚ self-adhesive copper metal tape
- ⊚ walnut stain
- ⊚ soft white acrylic paint
- ⊚ moss green glaze
- ⊚ tinted finishing wax
- ⊚ sepia calligraphy ink
- ⊚ brewed black tea
- ⊚ four brass escutcheon pins and brass-darkening solution
- ⊚ handheld saw
- ⊚ adhesives: PVA glue, hot-glue gun, collage medium (an equal mix of acrylic matte medium and water)
- ⊚ basic collage supplies (see page 12)

❧❧ STRATA ❧❧

This collage combines the techniques of frottage (taking a rubbing of a textured surface to create a design) and tissue-paper lamination to create layers of subtle color and texture. To establish the delicate color fields, Paula Grasdal tinted white tissue paper with water-mixable oil paints. She then encapsulated images of ammonites between layers of painted tissue, creating the look of fossilized impressions found in the earth's strata. The difference is that the translucency of the paper allows us to look within the layers to see the treasures buried there.

STEPS

1. Collect photographs, letters, and meaningful elements to use in your collage. Scan everything into a computer and print out on acid-free paper. Allow the printouts to dry thoroughly for a day. (You can also substitute color photocopies.) Arrange the images and handwritten text on the canvas until you find a placement that pleases you. Adhere with acrylic matte medium and smooth with a brayer.

2. Tear the corrugated cardboard into strips and use them to provide a partial frame for the main photograph.

3. Cover the entire canvas with a layer of matte medium. This will enable you to scratch back into subsequent paint layers without damaging the collaged elements.

4. With a clean brush, "veil" the photos with translucent buff paint. Let dry.

5. Use the acrylic paints to thinly glaze the blank areas of the canvas, cardboard, and parts of the photos, making sure to dry each layer thoroughly before applying the next. The paint should be put on very freely. You might like to add personal thoughts or messages by brushing on an opaque layer of the buff paint and etching in words with the end of the brush while the paint is still wet. Let dry, then apply further transparent glazes of paint. When you have finished, paint the sides of the canvas with black gesso.

6. If desired, brush thick gold paint on the "peaks" of the corrugated cardboard. Finally, apply a layer of gloss medium as a last step to help preserve the photos from the effects of sunlight and to give the painting a light varnish.

MATERIALS

- ☺ 12" × 12" (30 cm × 30 cm) gessoed canvas on heavy stretcher bars, 1¼" (3½ cm) deep
- ☺ reprinted or photocopied photographs
- ☺ handwritten text or letter
- ☺ acid-free paper
- ☺ white corrugated cardboard (craft type or recycled)
- ☺ fluid acrylics in transparent yellow oxide, crimson, gray, and buff
- ☺ tube paint in deep gold
- ☺ black gesso
- ☺ adhesives, acrylic matte meddium, acrylic gel medium
- ☺ basic collage supplies (see page 12)

☺ Ann Baldwin's Creativity Tips

Do more than one collage at the same time. Decide that one is "real" and the other is just messing around. This relieves the pressure of getting it right— and you'll be surprised how often the play collage turns out well. If you become stumped, run an errand, have lunch, and return to your work with fresh eyes. I place my problem paintings in odd corners of the house, where I come across them unexpectedly. In that split second I can view them objectively and often see what needs fixing.

⊙⊙ LIVONIA ⊙⊙

Embellished with a wide variety of collage
elements such as cancelled stamps, feathers,
shells, a tarnished silver spoon, buttons, maps,
and photocopies of vintage photographs, this
spirit house strongly evokes a sense of history and
place. Always on the lookout for interesting
faces, Carol Owen uses found photographs
prominently in her work. Rather than portraying
specific personal memories, she explores the
themes of family and memories of home in a
more general, universal way. By glazing over the
photos with a color wash, she integrates them
with the background; in this way, they look
almost like the memories of the people portrayed.

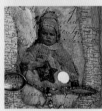

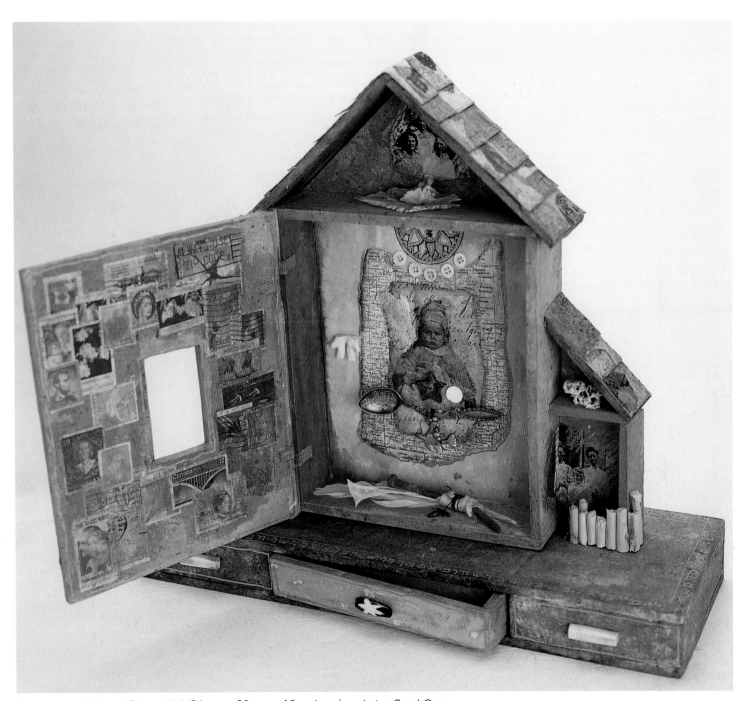

Dimensions: 14" h × 12" w × 4" d (36 cm × 30 cm × 10 cm) | Artist: Carol Owen

STEPS	MATERIALS

STEPS

1. Cut out the foam core to desired shapes (this project is essentially two boxes and a series of lean-tos). Paint both sides of the core with acrylic medium; this will prevent warping. Cover both sides of the core pieces with rice paper, smoothing out carefully to avoid puckering. Let dry.

2. Assemble the spirit house using the textile glue. Paint freely with acrylic paints. Let dry.

3. Arrange photos and other paper ephemera as desired, then glue down using the textile glue. While arranging the pictures, think about their relationship to each other as well as their placement in the context of the whole. This collage opens to reveal a regal baby at its center, sitting beneath a sun with button rays, on what appears to be a throne of maps, and holding a scepter-like spoon across its knees. The artist has provided a delightful surprise for anyone who looks inside the box.

4. Glaze over the surface with thin washes of the acrylics and blot. Go over edges of the collage elements and the house with metallic paints or pencils.

5. Embellish with small objects, gluing them in place with craft glue. Use the embellishments to draw attention to certain aspects of the collage. For example, when the door is closed, a handmade wooden frame highlights the peek-a-boo hole in its center. Fences made of pale wood in front of the side boxes serve to enclose the photos as well as to draw our eye to them.

6. Add thick "shingles" of decorative paper to the rooftops. Paint as desired, outlining the edges with metallic paint.

MATERIALS

☉ foam core

☉ rice paper

☉ photocopies of photographs

☉ various print materials such as maps, stamps, music paper

☉ embellishments such as shells, buttons, beads, coins, keys, jewels

☉ acrylic paints in various colors

☉ metallic paints

☉ adhesives: acrylic matte medium, textile glue, industrial-strength craft glue

☉ basic collage supplies (see page 12)

☉ Carol Owen's Creativity Tips

I take workshops and classes and go to seminars in all kinds of different media to keep ideas flowing. One of the most effective tools I've found comes from *The Artist's Way* by Julia Cameron—she calls it "filling the well." I keep binders of clippings of photographs, postcards, articles, and images that speak to me. Flipping through these books always stimulates my creativity.

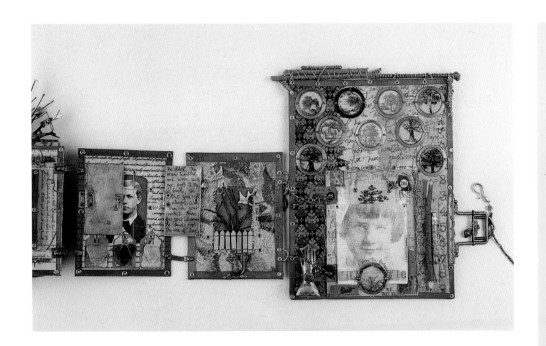

BOOK OF TREES

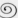

Using diverse found materials, Nina Bagley created a complex accordion–fold artist book inspired by memories of her Southern childhood, when trees were guardians and friends. The base is covered with antique optical testing lenses sandwiched over old photographs of trees. Attached to the base by vintage jewelry parts are six intricately decorated metal panels and a top panel of embossed leather, made from the cover of a Victorian photo album. A treasure trove of findings, Bagley's book is characterized as much by what is hidden as what is visible: a poem tucked into a transparent glassine envelope; a man's face just visible behind metal doors; words etched and pasted onto the backs of things.

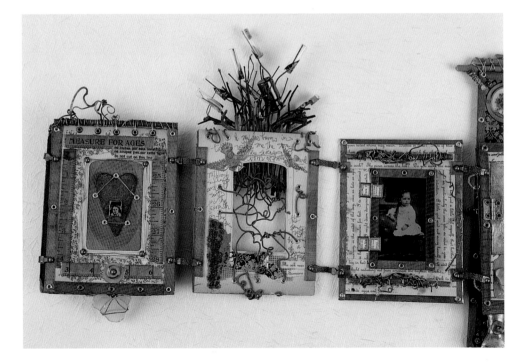

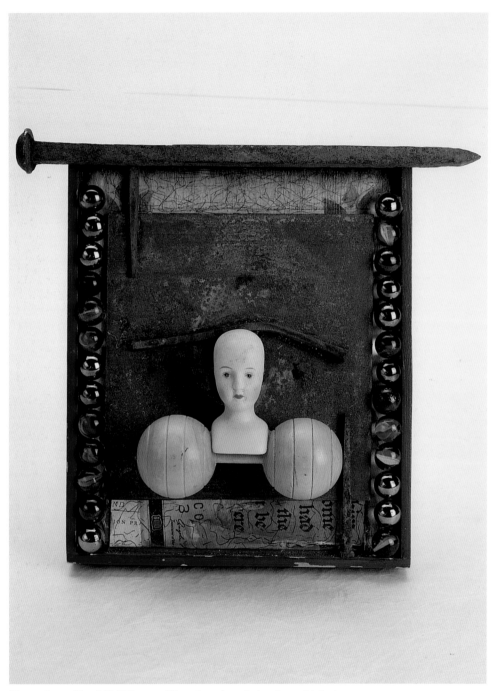

BALANCED HEAD

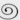

For this hanging assemblage mounted on a wooden cigar box lid, Janet Hofacker was inspired by the combination of the doll's head and wooden exercise tool (they seemed to "just fit together nicely"). By juxtaposing delicate porcelain with a rusted metal plate, she reveals and emphasizes the nature of each. The lightness of the porcelain doll head, tentatively balanced on its wooden wheels, makes a playful statement against the more serious, industrial character of the rusted metal backdrop and heavy spike frame. Glass marbles and pieces of a cut-up collage add visual interest and a further sense of whimsy.

Dimensions: 9" × 10" (23 cm × 25 cm) | Artist: Janet Hofacker

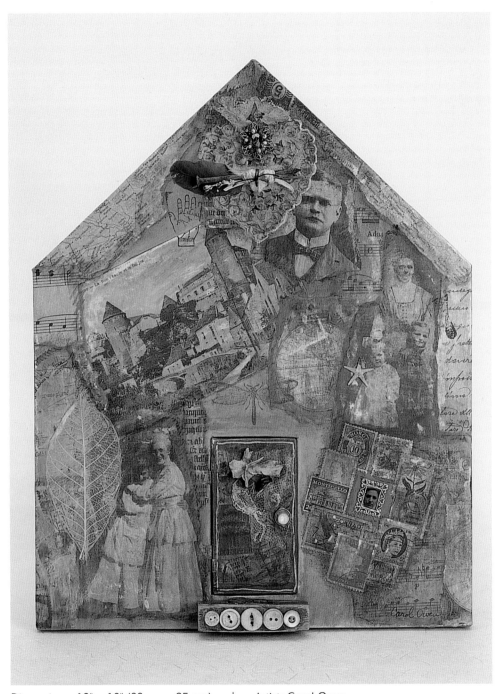

TIME REMEMBERED

Leaving room for people to invent their own narratives is key to the work of Carol Owen and this piece is a prime example. On a base of foam core covered in rice paper, she created a colorful shrine with washes of paint and embellishments such as vintage valentines and postcards, bits of lace and jewelry, and photocopies of old photographs. The heavily collaged and layered piece, with its haunting black-and-white images, offers tantalizing glimpses of past memories and half-told stories, whose completion depends on the imagination of the viewer.

Dimensions: 13" × 10" (33 cm × 25 cm) | Artist: Carol Owen

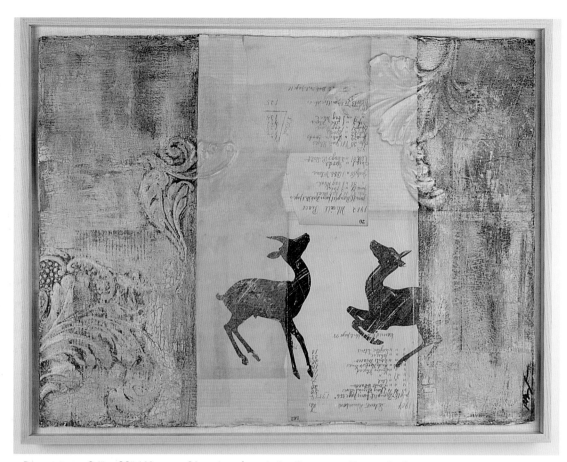

Dimensions: 24" × 32" (61 cm × 81 cm) | Artist: Rosemary Broton Boyle

UNTITLED

Rosemary Broton Boyle explores the themes of love and romance in this mixed-media collage, composed using layers of various papers, washes of acrylic paints and crackling glazes, and photo transfer techniques. The two deer symbolize a couple settling into the comfort of loving and being loved. Vintage ledger papers collaged on the surface represent love letters and communication while decorative elements such as the leafy embossed wallpaper and translucent rice paper add a romantic Victorian feel.

RENAISSANCE ARMOR

For this assemblage, a papier-mâché dress form collaged with paper and found objects, Janet Hofacker sought to use seemingly useless objects to make a work of art. To create depth, she worked in layers, beginning with torn pieces of parchment paper, followed by tissue paper and sections of lace. Once this first layer was dry, she painted the form using a sea sponge and three shades of diluted acrylic paint. After adding gold-leaf highlights, she let her imagination run wild, gluing on myriad embellishments: tassels, buttons, sequins, junk jewelry, rhinestones, and finials.

Dimensions: 20" × 8" (51 cm × 20 cm) with a 10" (25 cm) base | Artist: Janet Hofacker

BOOKS WILL GET YOU STARTED

❧

Making imaginative use of found objects, foam core, and a photocopy machine, Lynne Perrella reinvented a Victorian birdcage as a playful home for a paper theater. First she repaired the cage and cleaned it up with paint. Then she mounted archival prints of theaters, players, and antique books onto foam core to create the sets and actors, building another platform within the cage so she could house two theaters. The artist has created an atmospheric miniature world that celebrates the history of the English language.

Dimensions: 36" h × 24" w × 10" d (91 cm × 61 cm × 25 cm) | Artist: Lynne Perrella

BIBLIOGRAPHY

Ades, Dawn. *Photomontage*. New York: Thames and Hudson, 1976.

Bronner, Gerald F. *The Art of Collage*. Worcester, MA: Davis Publications, 1978.

Bruce-Mitford, Miranda. *The Illustrated Book of Signs and Symbols*. London: Dorling Kindersley, 1996.

Caws, Mary Ann, ed. Joseph Cornell's *Theatre of the Mind: Selected Diaries, Letters, and Files*. New York: Thames and Hudson, 1993.

Digby, Joan and John. *The Collage Handbook*. London: Thames and Hudson, 1985.

Fontana, David. *The Secret Language of Symbols*. San Francisco: Chronicle Books, 1993.

Goldsworthy, Andy. *A Collaboration with Nature*. New York: Henry N. Abrams, 1990.

Guiley, Rosemary Ellen. *The Encyclopedia of Dreams: Symbols and Interpretations*. New York: Crossroads, 1993.

Harlow, William M. *Art Forms from Plant Life*. New York: Dover Publications, 1966, 1976.

Hoffman, Katherine, ed. *Collage: Critical Views*. New York: State University of New York at Stony Brook, 1989.

Larbalestier, Simon. *The Art and Craft of Collage*. San Francisco: Chronicle Books, 1995.

Leland, Nita and Virginia Lee Williams. *Creative Collage Techniques*. Cincinnati: North Light Books, 1994.

Mattera, Joanne. *The Art of Encaustic Painting: Contemporary Expression in the Ancient Medium of Pigmented Wax*. New York: Watson-Guptill Publications, 2001.

McNiff, Shaun. *Trust the Process: An Artist's Guide to Letting Go*. Boston: Shambhala Publications, 1998.

Romano, Clare, and John and Tim Ross. *The Complete Printmaker*. New York: The Free Press, 1990.

Rothamel, Susan Pickering. *The Art of Paper Collage*. New York: Sterling Publishing Company, 2001.

Smith, Barbara Lee. *Celebrating the Stitch: Contemporary Embroidery of North America*. Newtown, CT: The Taunton Press, 1991.

Turner, Silvie. *Which Paper?* New York: Design Press, 1991.

Waldman, Diane. *Collage, Assemblage, and the Found Object*. New York: Harry N. Abrams, 1992.

Welch, Nancy. *Creative Paper Art: Techniques for Transforming the Surface*. New York: Sterling Publishing Company, 1999.

Wolfram, Eddie. *History of Collage*. New York: Macmillan Publishing Company, 1975.

Wright, Michael. *An Introduction to Mixed Media*. Scarborough, Ontario: Prentice Hall Canada, 1995.

RECOMMENDED READING

Atkinson, Jennifer L. *Collage Art: A Step-by-Step Guide and Showcase*. Gloucester, MA: Rockport Publishers, 1996.

Ayres, Julia. *Monotype: Mediums and Methods for Painterly Printmaking*. New York: Watson-Guptill Publications, 1991.

Cameron, Julia. *The Artist's Way: A Spiritual Path to Higher Creativity*. New York: G. P. Putnam's Sons, 1992.

Eichorn, Rosemary. *The Art of Fabric Collage: An Introduction to Creative Sewing*. Newtown, CT: The Taunton Press, 2000.

Frost, Seena B. *Soul Collage: An Intuitive Collage Process for Individuals and Groups*. Santa Cruz, CA: Hanford Mead Publishers, 2001.

Harrison, Holly and Paula Grasdal. *Collage for the Soul: Expressing Hopes and Dreams through Art*. Gloucester, MA: Rockport Publishers, 2003.

McRee, Livia. *Easy Transfers for Any Surface: Crafting with Images and Photos*. Gloucester, MA: Rockport Publishers, 2002.

Pearce, Amanda. *The Crafter's Complete Guide to Collage*. New York: Watson-Guptill, 1997.

ABOUT THE AUTHORS

Jennifer Atkinson received her M.A. in Art History from Boston University in 1983. She worked for a number of years at Clark Gallery, where she and her colleague Julie Bernson organized shows of found object and collage art. She has written book reviews for *Art New England*, a bimonthly publication, and has been appointed curator of the Fuller Museum of Art in Brockton, Massachusetts.

Holly Harrison is a freelance writer and editor. Her first craft book, *Angel Crafts: Graceful Gifts and Inspired Designs for 41 Projects*, was published by Rockport in April 2002. She has also contributed to numerous magazines, including *Metropolitan Home*. She and her husband recently moved to Concord, MA, where she finally has a room of her own for writing and crafting.

Paula Grasdal is a printmaker and mixed-media artist living in the Seattle area. She has contributed to several other Rockport publications, including *Angel Crafts: Graceful Gifts and Inspired Designs for 41 Projects*, *The Crafter's Project Book*, and *Making Shadow Boxes and Shrines*. Her work has been exhibited in galleries in the U.S. and Canada.